Ikebana Style

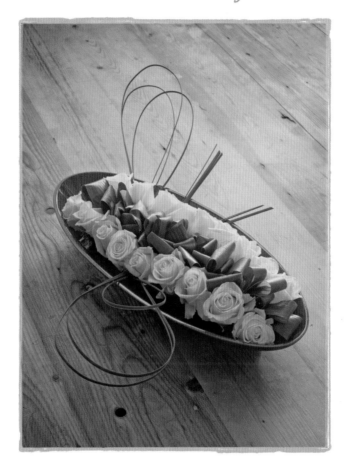

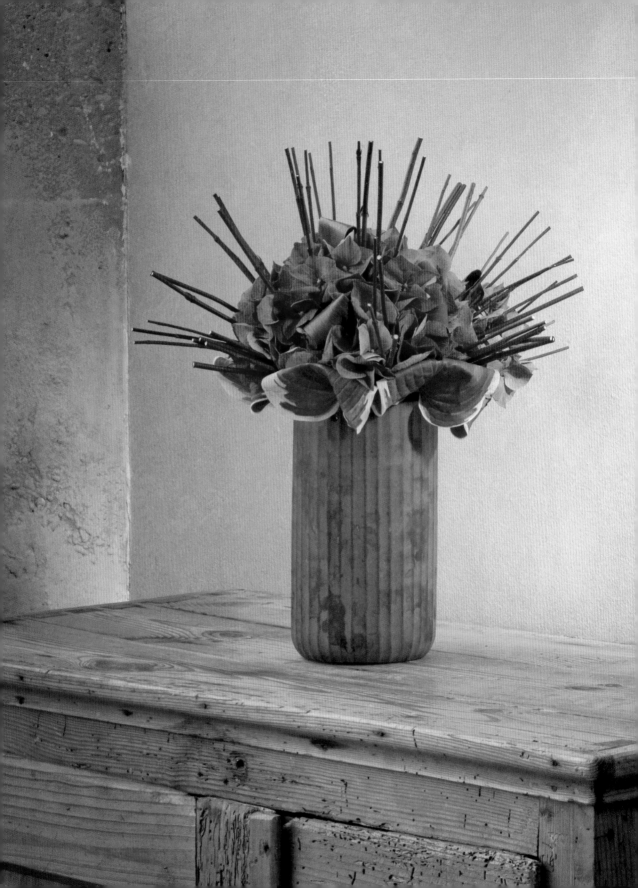

Ikebana Style

20 Portable Flower Arrangements Perfect for Gift-Giving

KEIKO KUBO

Photographs by Erich Schrempp

TRUMPETER BOOKS · BOSTON & LONDON · 2010

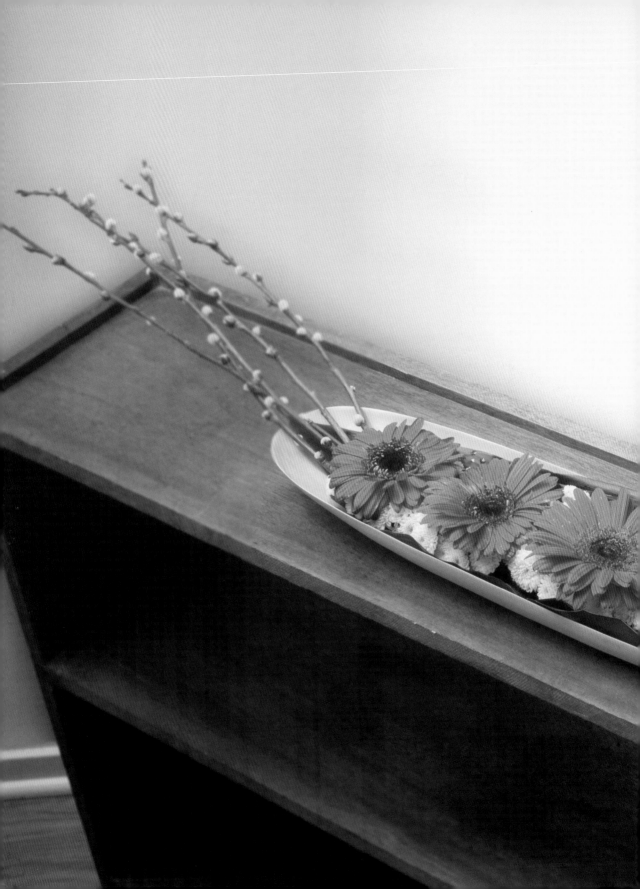

Contents

Introduction 7

The Basic Tools 38

Mitsumata in Glass Container 12/40

Wheat around Peonies 13/42

Aster Temari 14/45

Gift of Roses with Grass
 Bow 16/47

Orchids with Limes 17/50

Straight and Curved Lines
 in Harmony 18/52

Hydrangeas amid Dogwood
 Branches 19/55

Floral Gift Box 20/57

Roof over Dahlias 22/60

Tray of Calla Lilies 23/62

Horsetail Garden Fence 24/64

Floral Landscape 25/66

Horsetail Lines with Dahlias 26/68

Bamboo and Orchids in Moss
 Garden 28/70

Natural Lines in Basket 29/73

Calla Lilies and Green Grapes 30/75

Small Container
 Arrangement 32/78

Proteas in Round Tray 33/80

Gerberas in Boat Container 34/82

Orchids amid Fanned Grass 36/85

Acknowledgments 87

Resources 89

About the Author 93

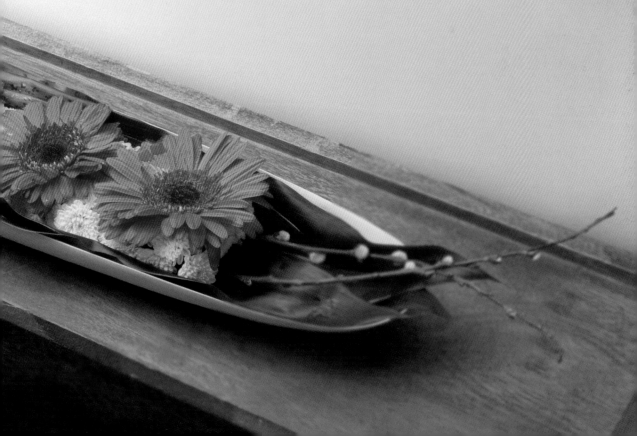

Introduction

MY FLOWER ARRANGEMENTS reflect my diverse background. I began taking ikebana classes as a young teenager growing up in Japan, and continued this training exclusively until my early twenties. I did not acquire Western floral training until moving to the United States to pursue advanced degrees in the fine arts; additionally, my background in sculpture inspired me to seek out new ideas in three-dimensional forms. Today my floral designs incorporate aspects of both Eastern and Western floral styles. My use of materials and composition stems mainly from my ikebana training, while I am also influenced by the construction and practicality of Western floral design. By combining my knowledge of ikebana, Western floral design, and sculpture, I have tried to create my own independent style that does not fit into one rigid category. I now work as an independent floral designer and do not belong to any particular school or organization.

Through practicing these two completely different styles of floral art, I've enjoyed the process of learning and combining the characteristics of each style. While I learned the aesthetics of simplicity, the use of minimal materials, and the beauty of the line element from ikebana, I found a different kind of beauty in the practical functionality of Western floral design and its emphasis on lush, portable arrangements.

One of the fundamental differences between these two forms is their contrasting approach to the concept of portability, which influences both how an arrangement is viewed and also how it is constructed. Ikebana arrangements are ordinarily created to adorn a specific site. Traditionally, ikebana was considered art to be displayed along with other artwork in the *tokonoma* (or "alcove") in the Japanese home, where guests were received. Although today ikebana is often placed elsewhere in the modern Japanese home, or in a public space, it is still ordinarily intended to be displayed in the specific site where arranged. Alternately, Western floral art usually emphasizes the notion of portability. Most of the time, arrangements are delivered from one place to another as gifts, for general decoration, or events and weddings. This notion of portability influences the size and overall look of

an arrangement. While traditional ikebana is often designed to be viewed primarily from the front and the side, my arrangements are usually intended to be viewed from all angles (front, back, and side), which is more typical of Western floral design. In this book, I've created arrangements which more closely adopt this Western perspective, and are therefore suitable to be displayed almost anywhere in the Western home.

The notion of portability also greatly influences the creation of Western floral art. In ikebana, the *kenzan* (or "frog"), a small strip of metal spikes, is the traditional means of floral mechanics used to secure floral materials. In the arrangements shown here, I've emphasized the portability of Western floral design by the use of portable containers and the related use of floral "mechanics," such as floral foam, to maintain the integrity of the arrangement for delivery. I have also employed many of the basic techniques and some tools often used in Western floral design. I support the flower stems using wired picks, for instance, or occasionally attach flowers to floral foam using an adhesive. For certain arrangements I also keep my flowers fresh using floral tubes.

While I have thus incorporated many Western techniques into the arrangements here, I still draw on my ikebana training to incorporate an Eastern design aesthetic. I often use an asymmetric composition and a minimal variation of materials, for instance. Western arrangements tend to employ a greater variety of materials. Instead of mixing various flowers, however, I try to use just a few types of flowers in each arrangement. I also emphasize the use of lines—a key element of ikebana—utilizing the flowers, foliage, and branches.

The more I've learned about the distinct characteristics of these two styles, the more I have become interested in combining them in my work. This book has given me the opportunity to pursue and share my love of creating designs that blend these two styles. Here I present twenty portable floral designs that represent the theme of ikebana style gift arrangements. By gift arrangements I mean works that can easily be delivered from one place to another, although as you will see they do not all involve making small arrangements in a box or basket. Through my freestyle ikebana form, I have tried to create arrangements to express ideas that come from my varied floral art and artistic training. I truly hope you enjoy them and will find some creative inspiration of your own. ⁓

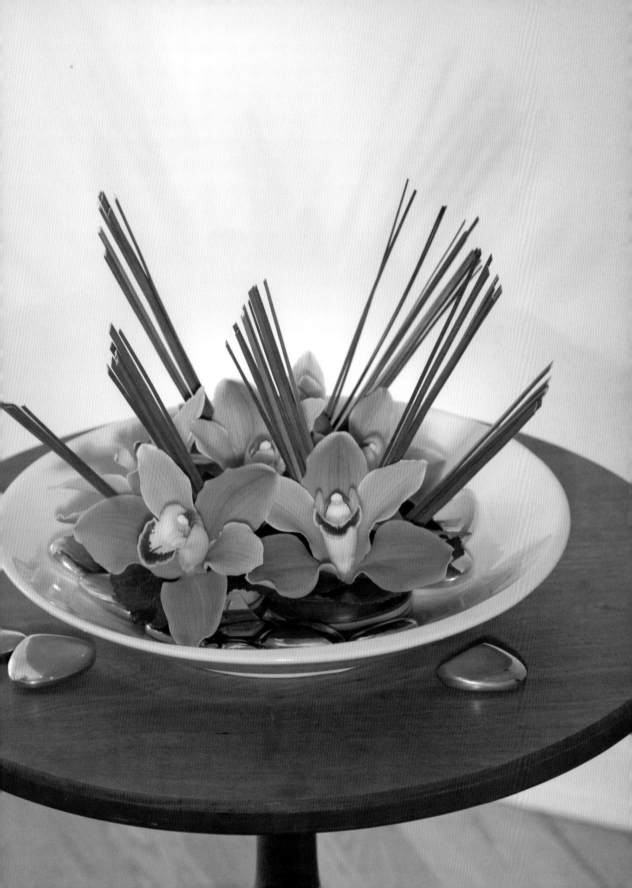

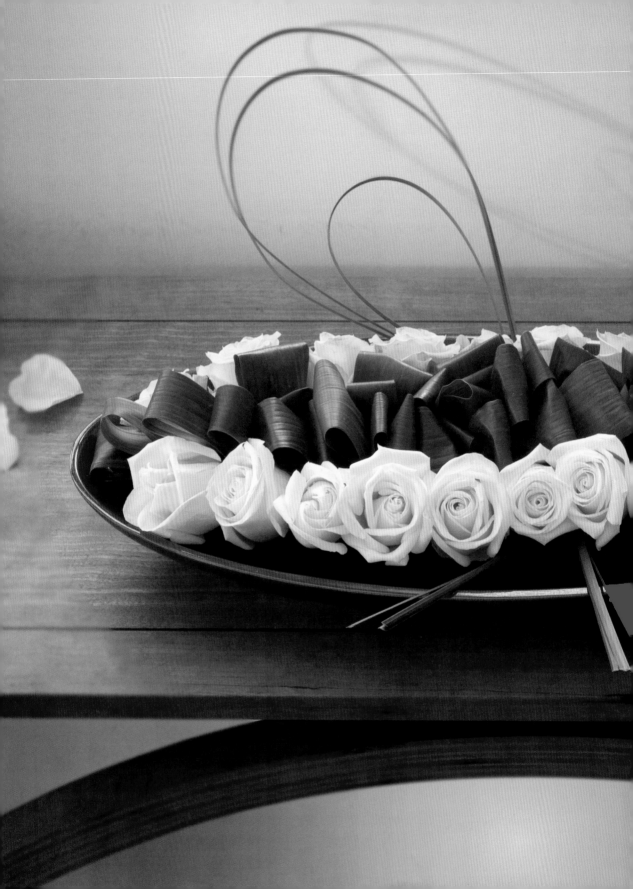

The Arrangements

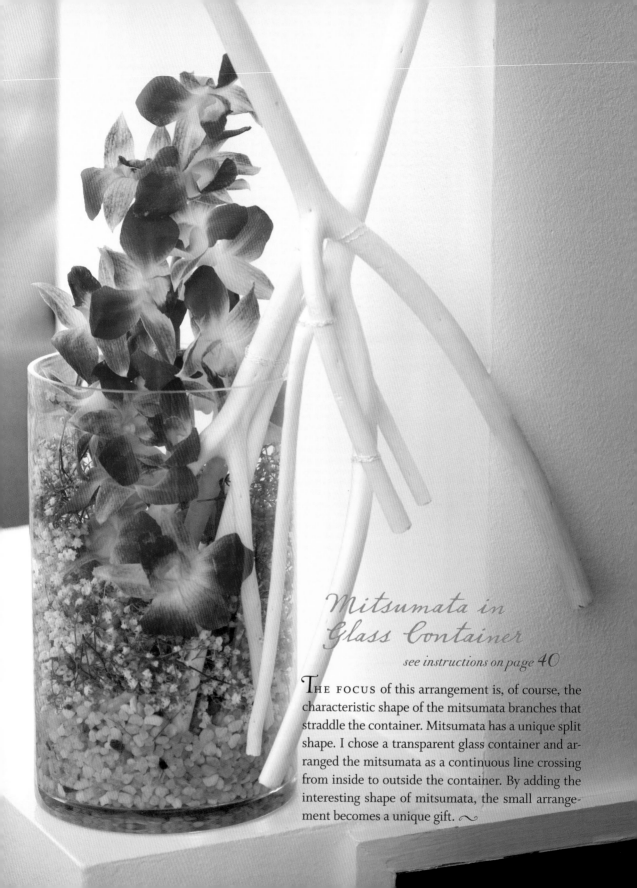

Mitsumata in Glass Container

see instructions on page 40

THE FOCUS of this arrangement is, of course, the characteristic shape of the mitsumata branches that straddle the container. Mitsumata has a unique split shape. I chose a transparent glass container and arranged the mitsumata as a continuous line crossing from inside to outside the container. By adding the interesting shape of mitsumata, the small arrangement becomes a unique gift. ∼

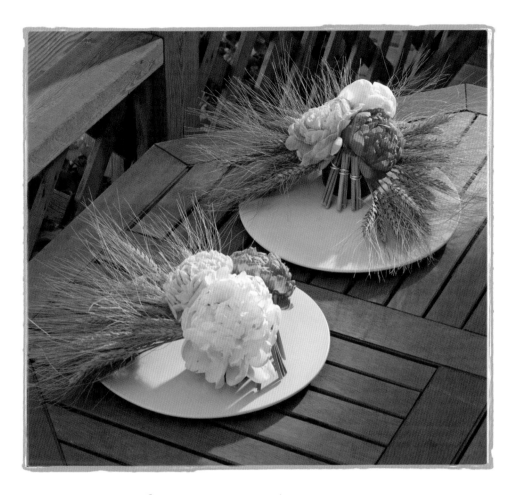

Wheat around Peonies

see instructions on page 42

Lᴀʏᴇʀs of wheat lines are displayed in these two arrangements, which halfway encircle each of two dish containers. I tried to create a direct relationship between the two. If placed together, they would make a complete circle. ∿

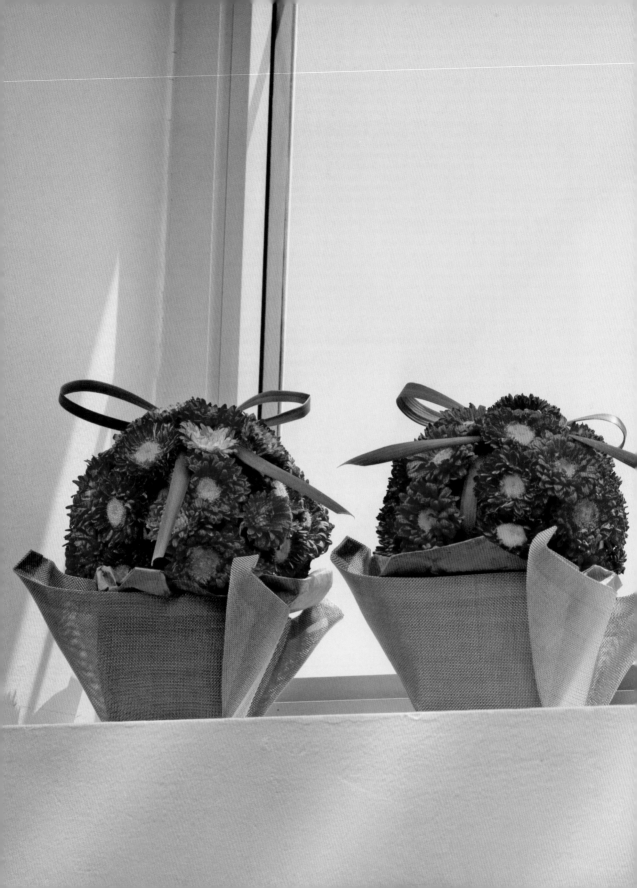

Aster Temari

see instructions on page **45**

My IDEA came from the Japanese sphere-shaped decoration called a *temari*. I attached Aster Matsumoto to sphere-shaped foam to create my two ikebana temari, and displayed them in mesh containers. ∿

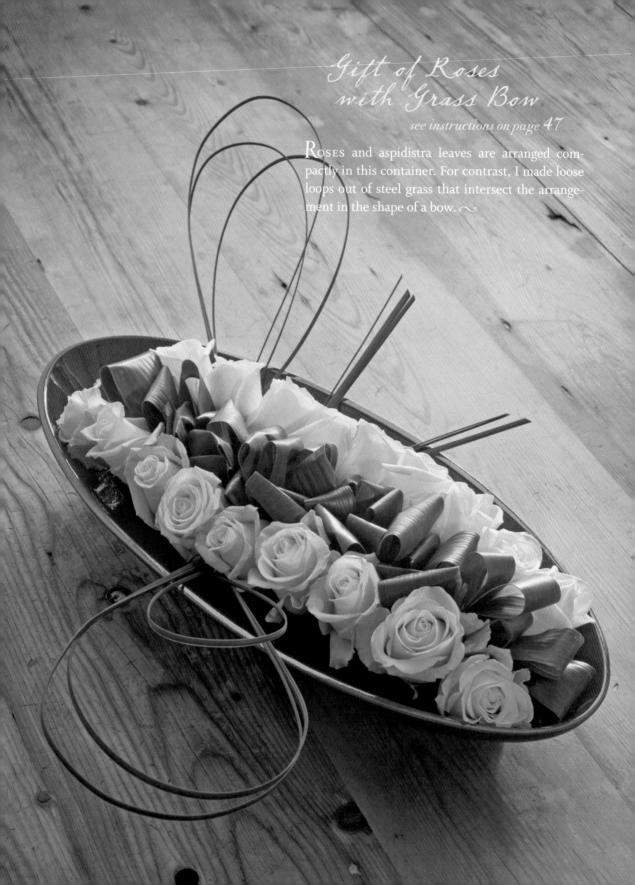

Gift of Roses with Grass Bow

see instructions on page 47

Roses and aspidistra leaves are arranged compactly in this container. For contrast, I made loose loops out of steel grass that intersect the arrangement in the shape of a bow. ～

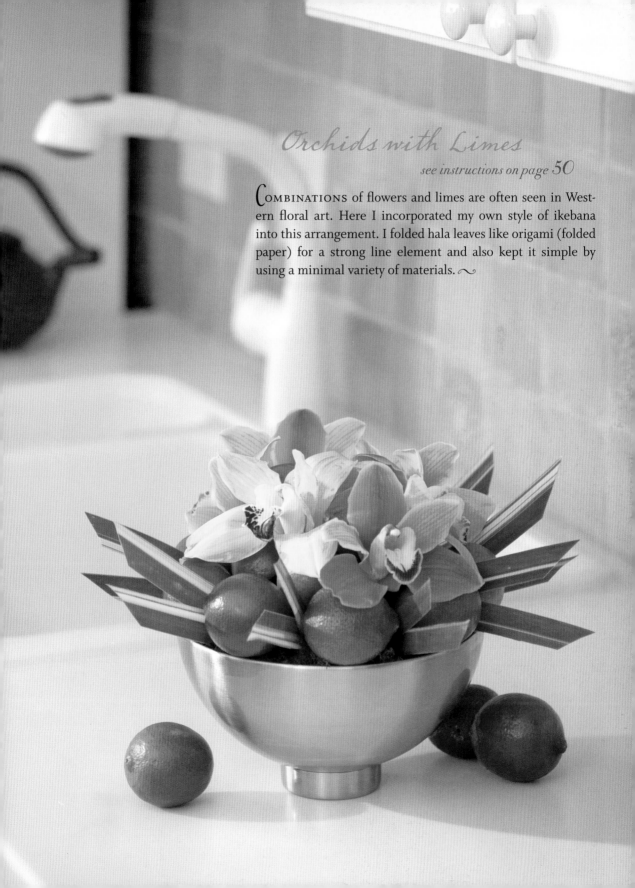

Orchids with Limes

see instructions on page 50

COMBINATIONS of flowers and limes are often seen in Western floral art. Here I incorporated my own style of ikebana into this arrangement. I folded hala leaves like origami (folded paper) for a strong line element and also kept it simple by using a minimal variety of materials. ∿

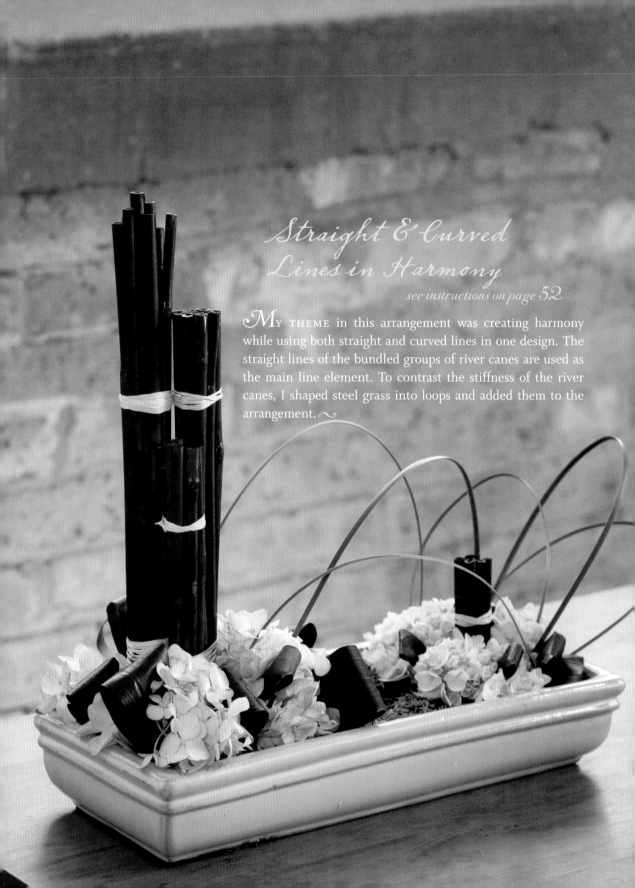

Straight & Curved Lines in Harmony

see instructions on page 52

My theme in this arrangement was creating harmony while using both straight and curved lines in one design. The straight lines of the bundled groups of river canes are used as the main line element. To contrast the stiffness of the river canes, I shaped steel grass into loops and added them to the arrangement. ∾

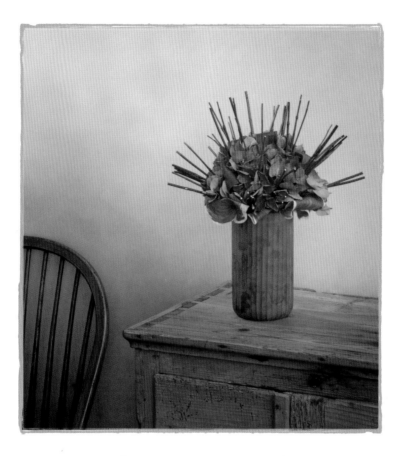

Hydrangeas amid Dogwood Branches

see instructions on page 55

Branches naturally have their own unique lines we can use in our arrangement, but we can also make interesting lines by trimming, shaping, or bundling them. In this arrangement I trimmed excess lines from dogwood branches and made groups of branches. Adding lines to the mass of hydrangeas from multiple angles gives a unique look and fills out the form. ~

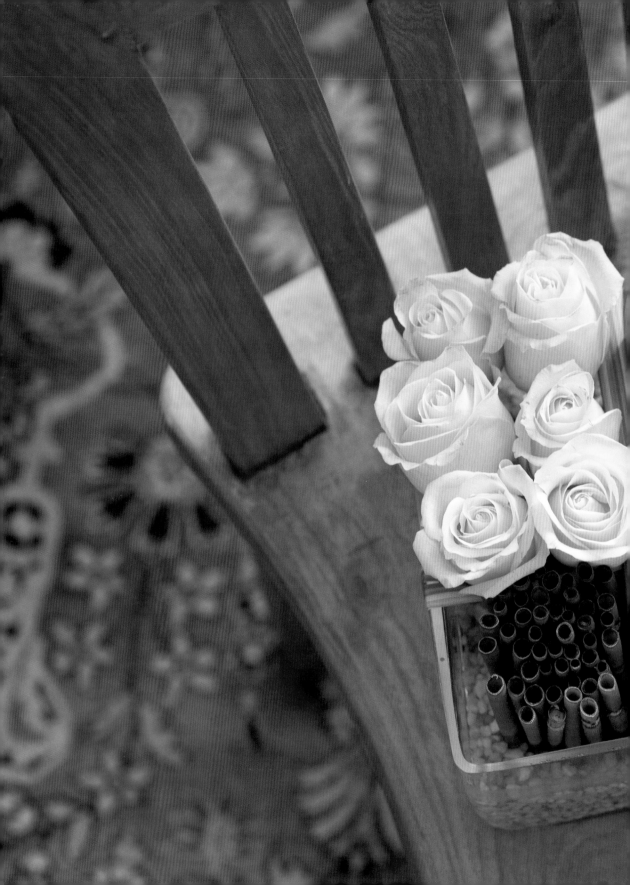

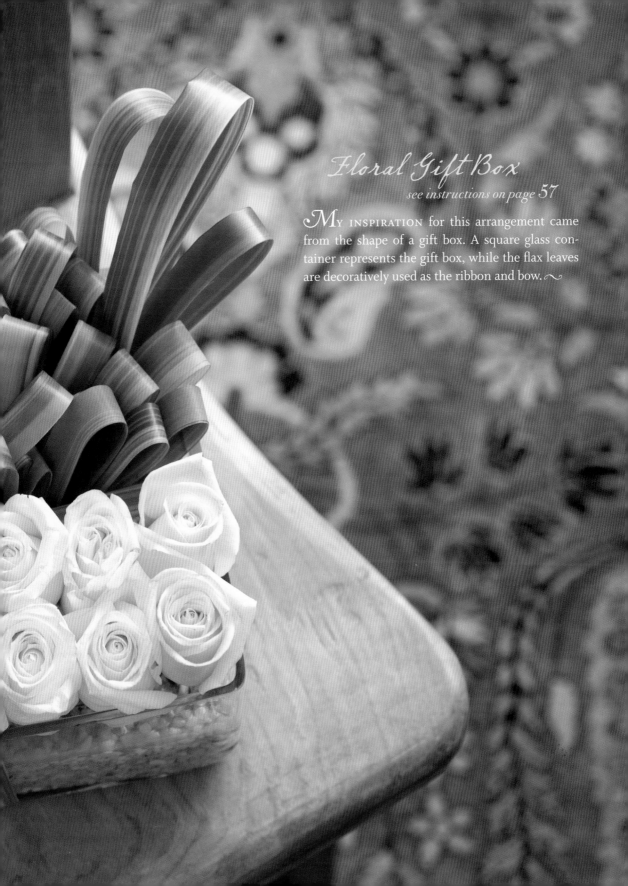

Floral Gift Box

see instructions on page 57

My inspiration for this arrangement came from the shape of a gift box. A square glass container represents the gift box, while the flax leaves are decoratively used as the ribbon and bow. ～

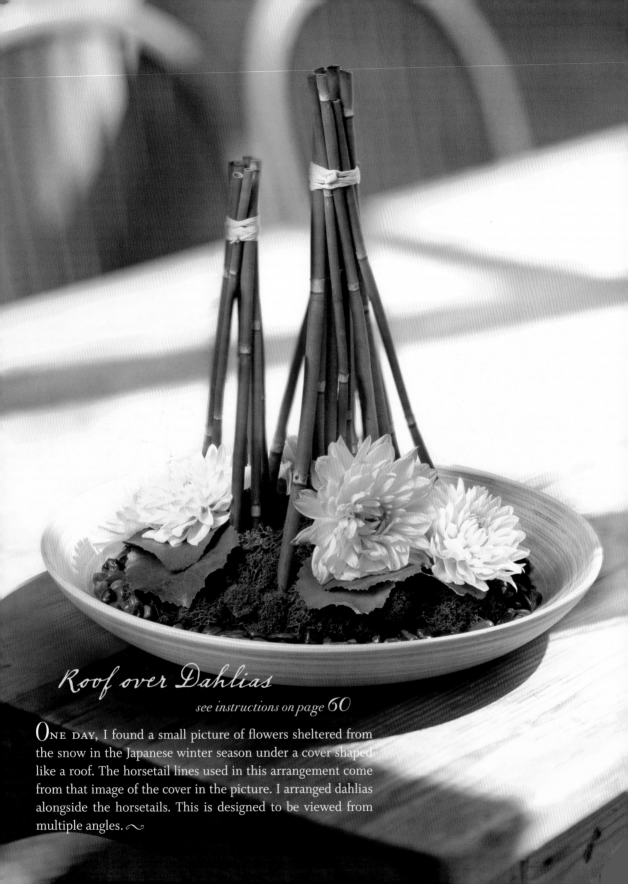

Roof over Dahlias

see instructions on page 60

ONE DAY, I found a small picture of flowers sheltered from the snow in the Japanese winter season under a cover shaped like a roof. The horsetail lines used in this arrangement come from that image of the cover in the picture. I arranged dahlias alongside the horsetails. This is designed to be viewed from multiple angles.

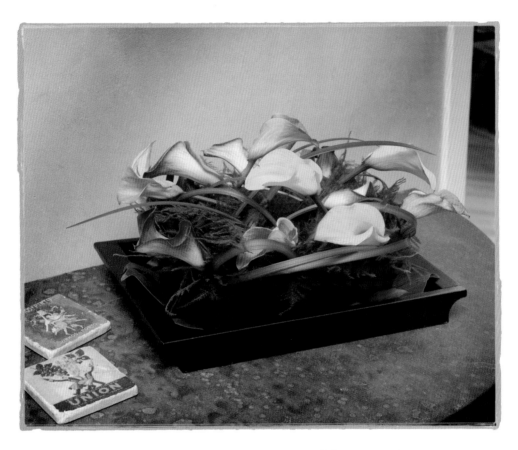

Tray of Calla Lilies

see instructions on page 62

IN ORDER TO PRESENT the beautiful color and shape of calla lilies, I wanted to use a simple container. I simply wrapped leaves around the small plastic cups used as containers. Multiple numbers of small cups are displayed on the tray so that the arrangement becomes portable. ∿

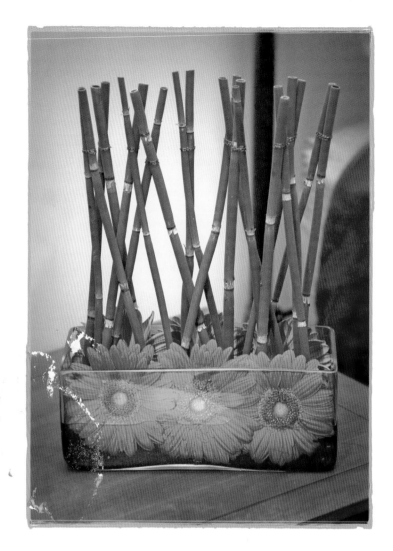

Horsetail Garden Fence

see instructions on page 64

MY INSPIRATION for this arrangement was the bamboo fence in the traditional Japanese garden, called a *kakine*. I used horsetails instead of bamboo to create my small fence in the container. The gerberas are cut short and arranged almost entirely inside the glass container in order to emphasize the lines of the horsetails. ～

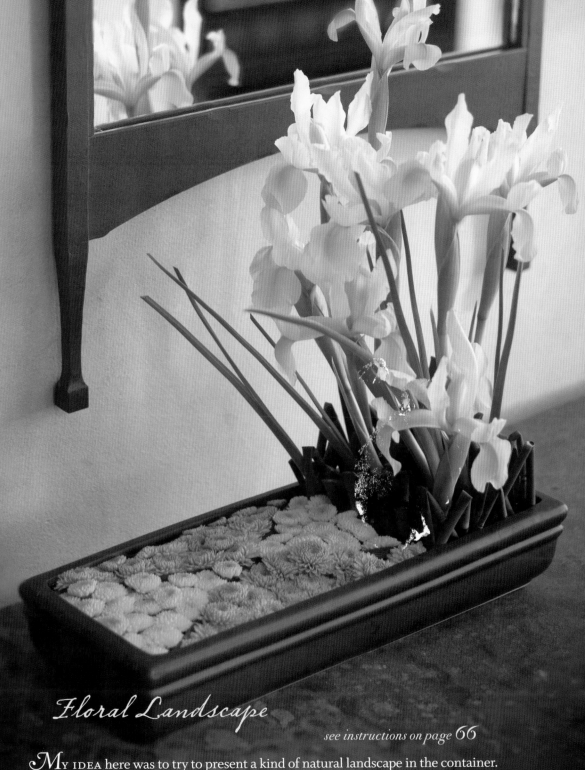

Floral Landscape

see instructions on page 66

My IDEA here was to try to present a kind of natural landscape in the container. Half of the container is designed with a geometric pattern of chrysanthemums that represents a field, while the other half presents the iris naturally, as if in the garden. To connect the two designs I chose the same color group for both sides. ∼

Horsetail Lines
with Dahlias

see instructions on page 68

THE STRONG use of lines is the theme of this arrangement. Horsetails inside the glass container are placed horizontally to hide the foam but become part of the design. I also arranged horsetails of different lengths diagonally in opposite directions to create an asymmetric composition. ∿

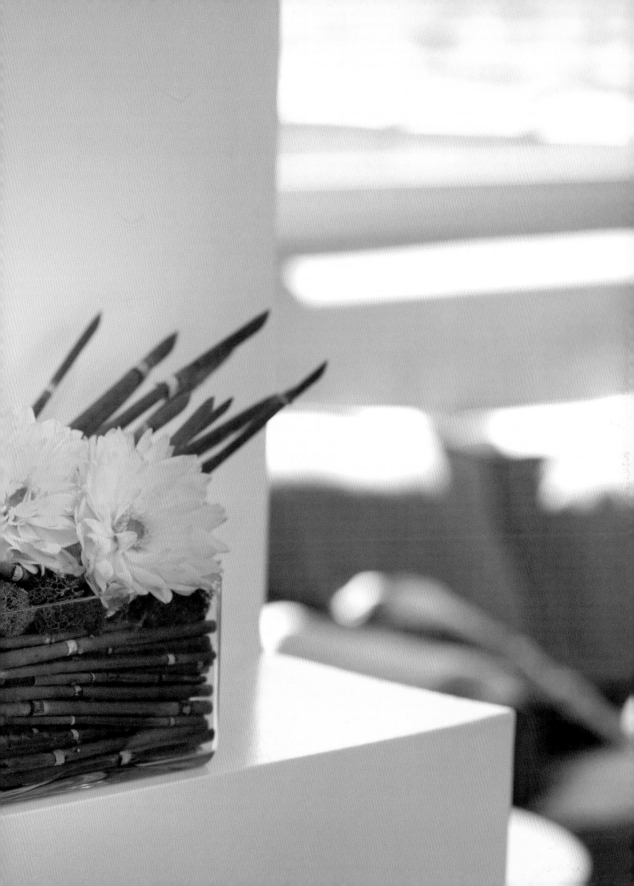

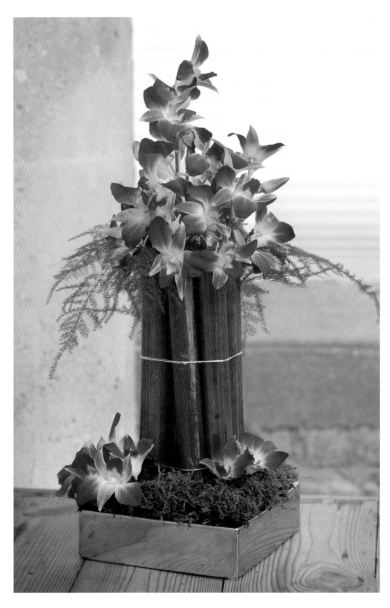

Bamboo & Orchids in Moss Garden

see instructions on page 70

I MADE this arrangement using rather traditional materials—bamboo, orchid, and moss—in a modern-looking container. The orchids placed on the moss along the bottom are a subtle detail, but are important to connect the bamboo and container as one.〜

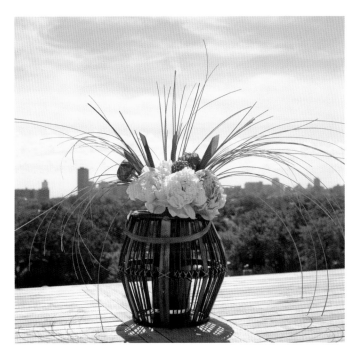

Natural Lines in Basket

see instructions on page 73

THE IMAGE of a natural-looking arrangement came to my mind when I found this basket. I deliberately chose large flowers for this tall basket, and I loosely arranged the grasses inside to finish the simple, natural look. ∿

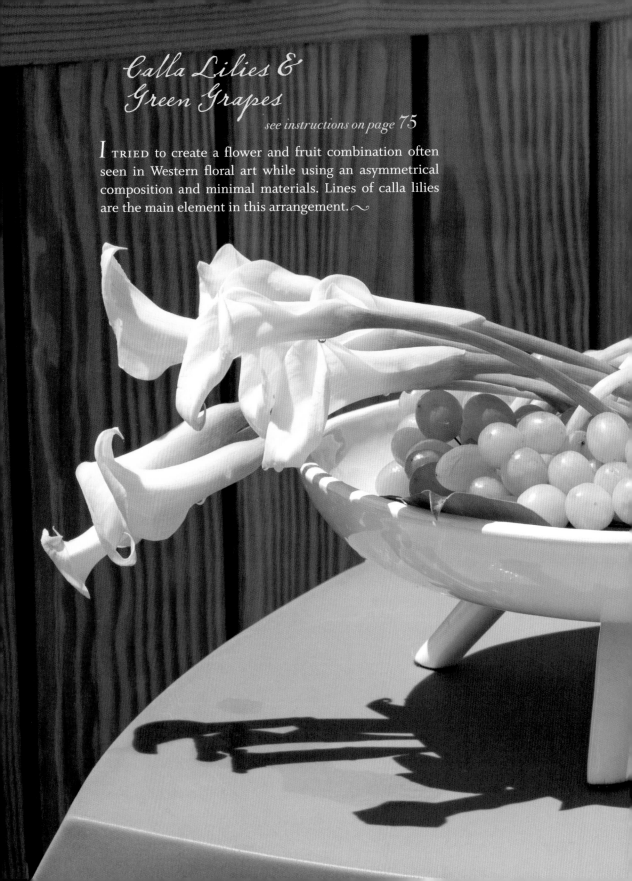

Calla Lilies & Green Grapes

see instructions on page 75

I TRIED to create a flower and fruit combination often seen in Western floral art while using an asymmetrical composition and minimal materials. Lines of calla lilies are the main element in this arrangement. ∿

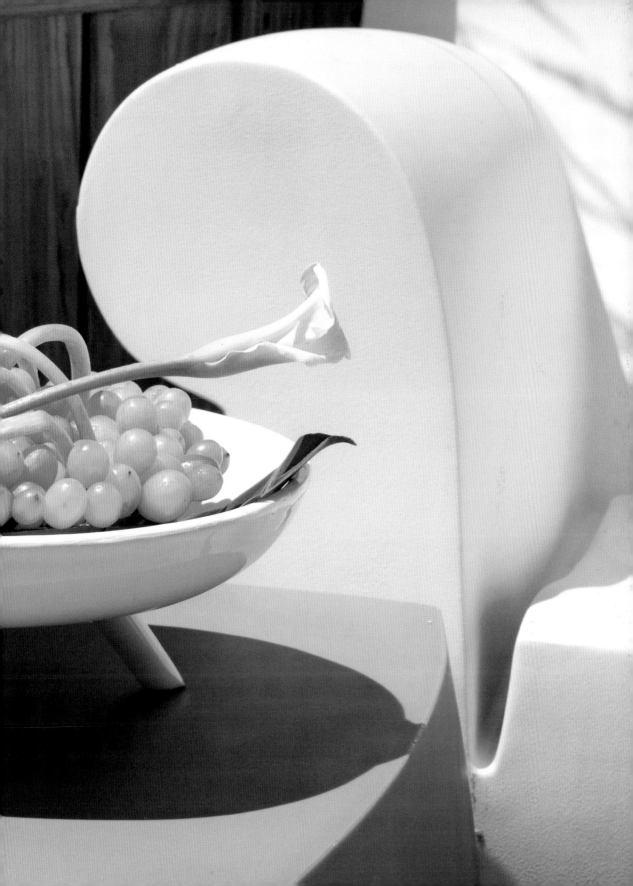

Small Container Arrangement

see instructions on page 78

ADDING DEPTH and volume to an arrangement in a small container was my theme for this design. Each of the three materials (river canes, leaves, and flowers) is arranged in a group to add volume. Using one of the container's pointed angles as the front side of the arrangement also helps to add depth.

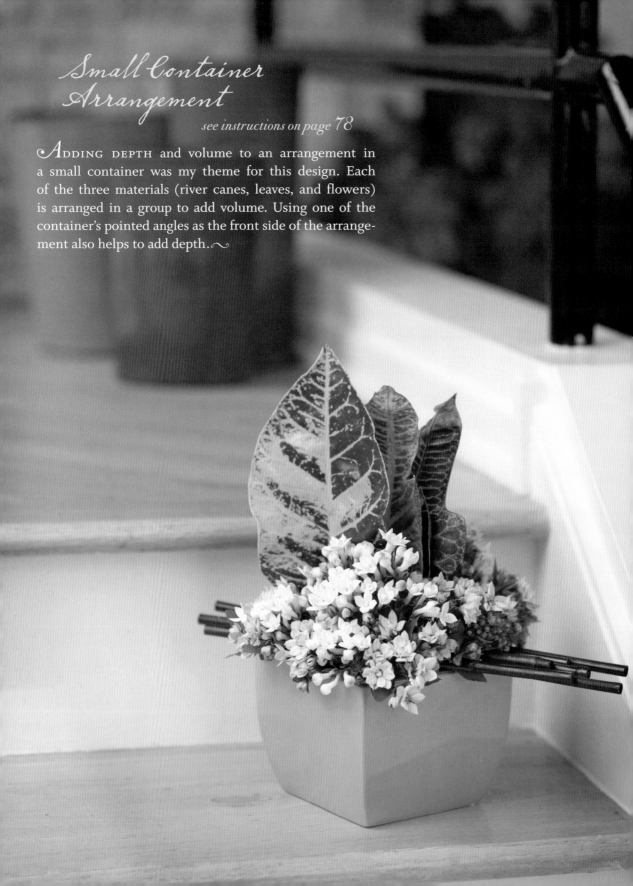

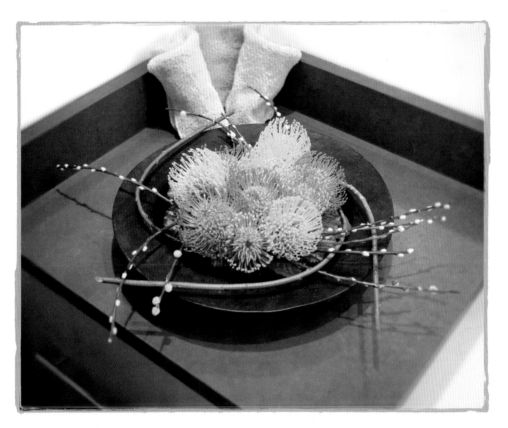

Proteas in Round Tray

see instructions on page 80

CREATIVE IDEAS can come from various sources, often from simply studying a container or materials at hand. When I found this wooden tray, I thought that the color and texture of proteas would work well with it. I used lines of pussy willow along the round edges of the tray and then arranged the orange and yellow proteas in the tray as an accent. ∽

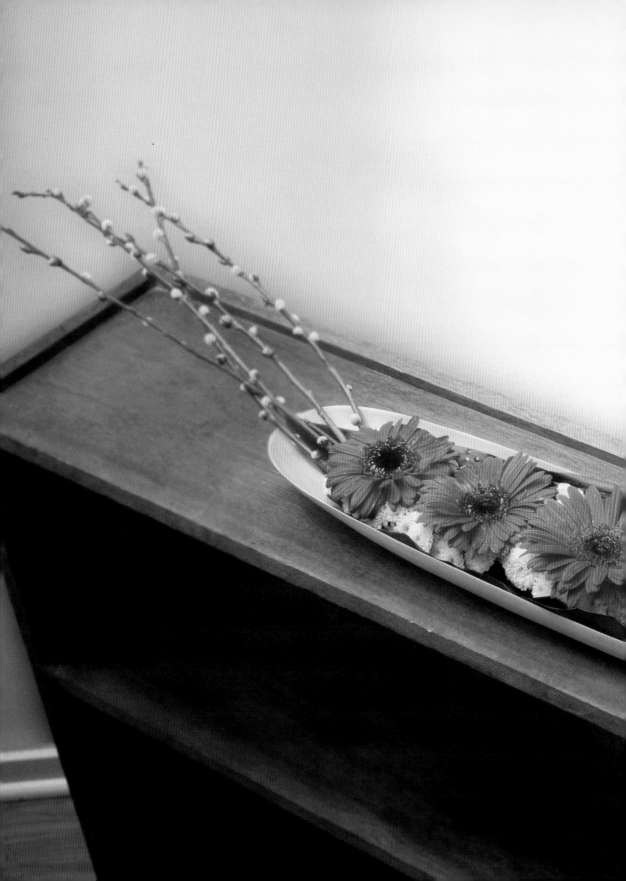

Gerberas in
Boat Container

see instructions on page 82

THIS ARRANGEMENT in a boat-shaped container is designed to be viewed from the top down. The lines of pussy willow are important in this design. Without these lines, the arrangement looks flat and rigid. By adding lines, it breaks the rigidity and also adds depth to the composition.

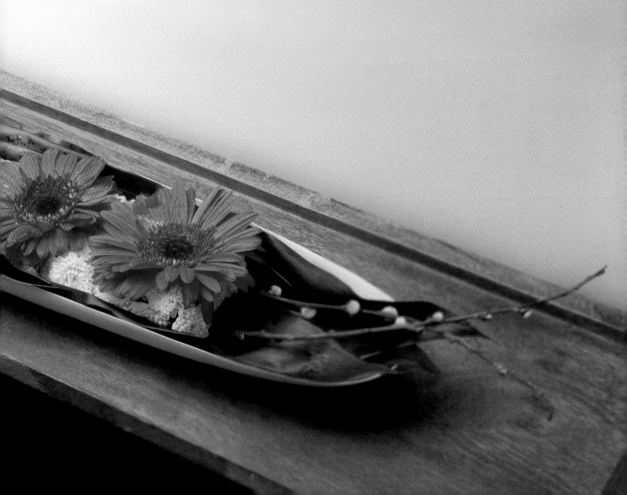

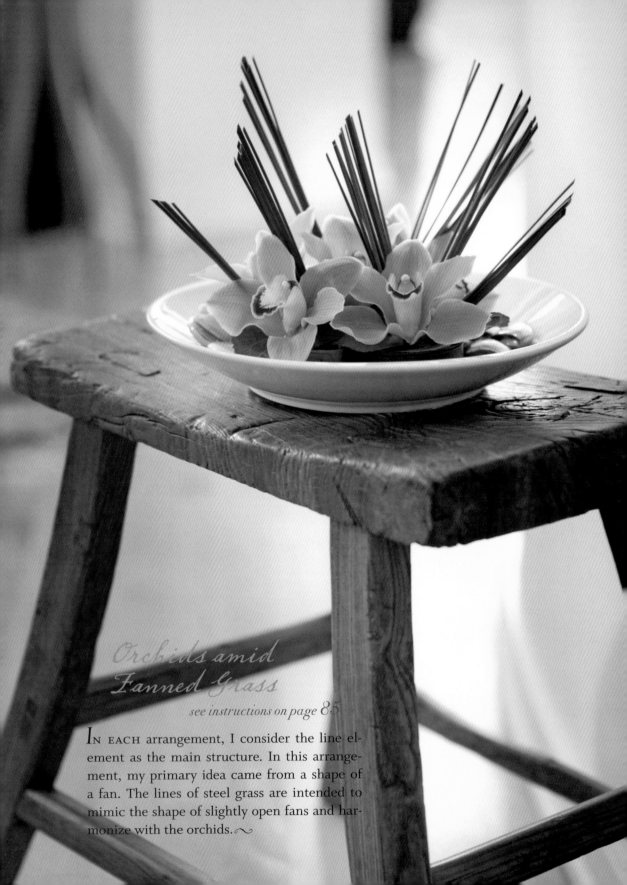

Orchids amid
Fanned Grass
see instructions on page 85

IN EACH arrangement, I consider the line element as the main structure. In this arrangement, my primary idea came from a shape of a fan. The lines of steel grass are intended to mimic the shape of slightly open fans and harmonize with the orchids. ～

How to Make
the Arrangements

The Basic Tools

THESE ARE THE BASIC TOOLS I often use for my arrangements, which you'll find helpful when you make the arrangements in this book. The resources section lists stores that will ship these items if you cannot find them locally.

[Floral Foam]

Variations of floral foam are used frequently in Western floral art to secure materials and hold water that will help keep arrangements fresh. When making an arrangement that will be transported to another location, I ordinarily use common brick floral foam and cut it to fit different containers. Sphere-shaped foam is also available.

[Scissors]

I was trained in making arrangements using ikebana scissors, so I mainly use ikebana scissors or clippers when creating my designs. Clippers are useful to cut wire.

[Green Floral Wire]

Green floral wire is available in a variety of different gauges. The gauge of wire used depends on the task at hand and the materials in the arrangement.

[Wired Picks]

Wired picks are very useful to support the stems of flowers or foliage that will be inserted into foam. These picks can also be useful without the wire to attach fruit, foam, or other dense objects to foam. I refer to wired picks with the wire removed as "wooden picks."

[Floral Tube]

The floral tube is also a common item used to keep flowers and foliage fresh in water.

[Regular or Double-Sided Tape]

I sometimes wrap a plastic cup or liner with leaves using regular or double-sided tape in order to hide the floral foam inside.

I choose different types of floral adhesive depending on the function. When I need to attach a plastic cup or liner to a container for transport, I like to use a temporary type of floral adhesive that can be detached later on. I'll use a more permanent type of floral adhesive when I want to attach something securely, such as when I attach flowers to spherical foam, for instance, so they won't fall off during transport.

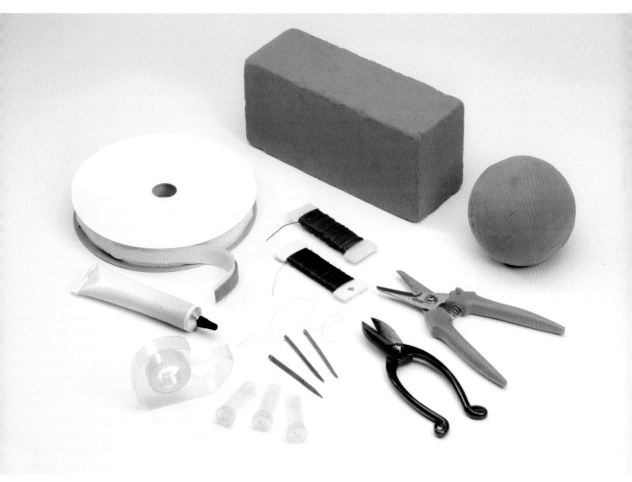

Mitsumata in Glass Container

[CONTAINER]
Cylindrical glass container

[MECHANICS]
Water tubes

[MATERIALS]
Mitsumata
Dendrobium
Baby's breath
Small white gravel
Silver bullion wire

STEP 1

For this step, tie the branches of mitsumata together with wire (see Technique 1) and place them partially inside the container, using the gravel as a support mechanism. The trick to this step is assembling the branches properly so they'll fit inside the container. Before tying them, arrange the branches inside the container the way you would like. Carefully pull them out and tie them together, then place them as shown.

STEP 2

Cut the baby's breath into small sections and place them on the gravel in the container.

THE FINISHED ARRANGEMENT

Insert each stem of dendrobium into the floral tube and arrange them between the baby's breath. Be sure the tube is completely covered by baby's breath. Pictured on page 12.

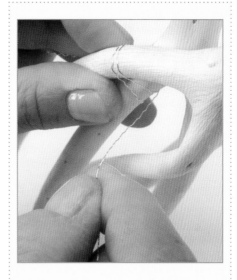

Technique 1

Tie the mitsumata branches with silver bullion wire by placing the branches together and winding the wire around them a few times. This will allow the branches to sit firmly and stand upright in the container.

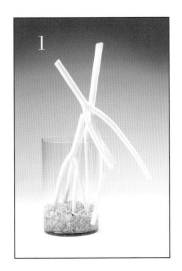

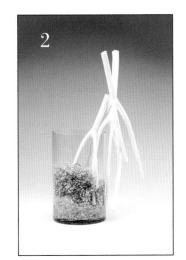

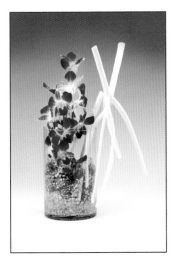

Wheat around Peonies

[CONTAINER]

Round dish container (two—optional)
Small plastic cup (two—optional)

[MECHANICS]

Floral foam

[MATERIALS]

Wheat
Peony (dark pink, pink, and white)
Aspidistra
Silver aluminum wire

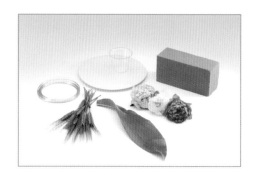

STEP 1

First, cut the aspidistra leaves into lengthwise pieces about the same height as the plastic cups and wrap the plastic cups with aspidistra leaves using double-sided tape. Next, place enough foam inside of each cup so that it stands slightly above the rim. (See the Basic Tools section on page 38 describing the use of regular or double-sided tape and floral adhesive.)

Place the wrapped cup on the container using a temporary floral adhesive to secure it in place. Repeat using your second cup and container if you are using one. (Note that I created two complementary arrangements using the same materials, although you certainly may create only one arrangement, or more than two, if you wish.)

STEP 2

Insert layers of wheat along the edge of the raised foam as shown. Stop after going two-thirds of the way around. Repeat with the other cup but stop after going one-third of the way around.

STEP 3

Arrange short-cut peonies and cover the foam with them.

THE FINISHED ARRANGEMENT

Cut a quantity of short wheat stems sufficient to cover the remaining foam and tie them together into small groups (see Technique 2). Cover the side of the foam with the grouped stems. Pictured on page 13.

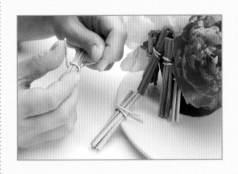

Technique 2

Cut the wheat stems into short, equal-length pieces and bundle them into small groups with wire. Use the ends of the wire to attach the stems into the foam. Although the wire serves a practical function, I specifically used silver aluminum wire as one of my design elements.

1

2

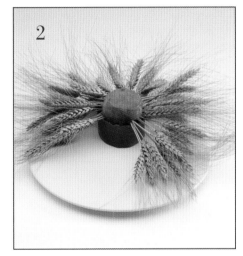

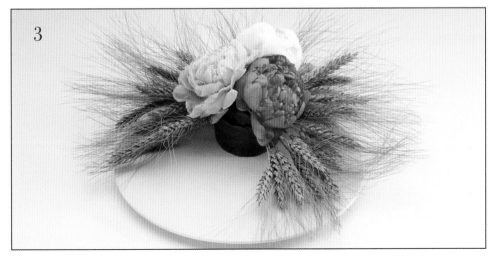

3

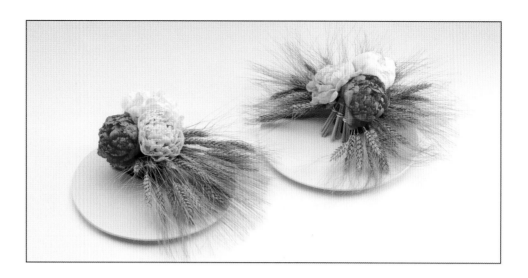

Aster Temari

[CONTAINER]

Mesh container (two—optional)
Plastic cup (two—optional)

[MECHANICS]

Floral foam (sphere and brick shape)
Colored paper

[MATERIALS]

Aster Matsumoto (red and violet)
Lily grass

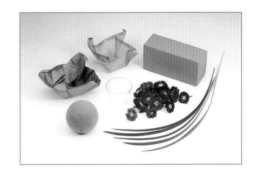

STEP 1

Slice off the bottom of the sphere-shaped foam to help it sit securely on the flat surface of the other foam. Wrap the foam with lily grass (see Technique 3). Attach some wooden picks (I used wired picks with the wire removed) to your sphere-shaped foam and use these to attach the sphere to the small brick foam placed in the cup. (Note that I created two identical arrangements using the same materials, so these steps may simply be repeated to create as many additional arrangements as you wish.)

STEP 2

Cut the Aster Matsumoto short and attach each individual flower to the foam between the lines of lily grass (see Technique 4). Then make a bow shape out of lily grass and place it on top of the arrangement.

THE FINISHED ARRANGEMENT

Line the container with the colored paper and place the arrangement in the container. (The paper is used to fill gaps between the cup and the container and also helps keep the arrangement standing straight up.) Pictured on pages 14–15.

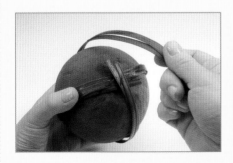

Technique 3

Here I used about six leaves of lily grass to wrap the sphere-shaped foam. Start by pinning the ends of two leaves to the foam with U-shaped green wire (see Technique 21), wrap it around the center of the foam as far as you can and attach the other end to the foam with green wire again. Repeat the same process with your remaining leaves, crossing your original leaves as shown.

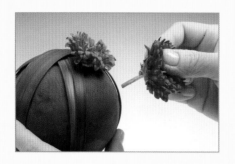

Technique 4

Cut the stems of the Aster Matsumoto short to attach them to the spherical foam. Wired picks or floral adhesive are very helpful tools to attach the flowers to the spherical foam securely. (See the Basic Tools section on page 38 describing the use of floral adhesive and wired picks.) Keep in mind that flowers are more difficult to secure to spherical foam and can easily fall off during transport.

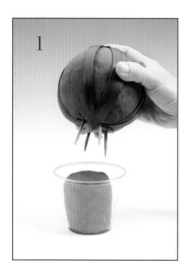

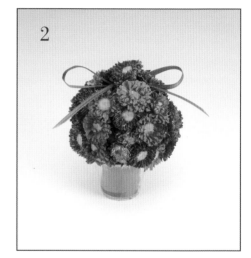

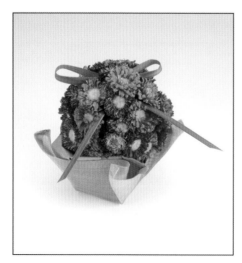

Gift of Roses with Grass Bow

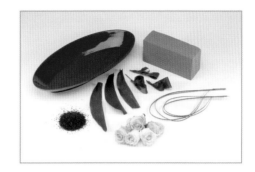

[CONTAINER]

Oval container

[MECHANICS]

Floral foam

[MATERIALS]

Rose (white and green)
Aspidistra
Steel grass
Fine black gravel

STEP 1

Cut the foam to match the precise shape of your container, as shown. Place the foam down the center of the container and place gravel around the foam. The gravel is used for both decoration and to stabilize the foam in the container. Note that I have cut the ends of the foam in a triangular shape that makes it easier to hide while using less materials.

STEP 2

Place the folded aspidistra leaves horizontally down the center of the foam (see Technique 5).

STEP 3

Arrange roses on both sides of the folded aspidistra leaves. I arranged one side with yellow roses and the other side with white roses, although this is optional. Place the roses at slight angles to help cover the edge of the foam.

THE FINISHED ARRANGEMENT

Make some large loops out of steel grass and insert them into the foam to create a bow shape (see Technique 6). Adding a few short, straight lines of steel grass gives the illusion of a bow passing through the arrangement. Look at the arrangement from the top and add more folded aspidistra leaves to cover the foam if necessary. Pictured on page 16.

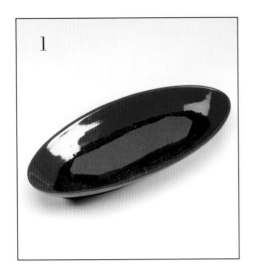

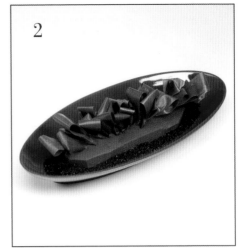

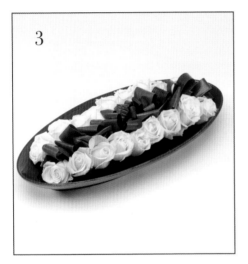

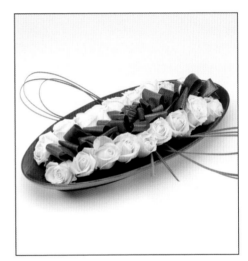

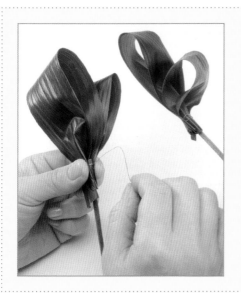

Technique 5

I often use folded leaves in my arrangements. You can make a single-folded leaf, double-folded leaves, or use even more leaves if you'd like. In this arrangement I used double-folded leaves. First, cut the aspidistra leaves into small strips. Then fold the leaves in half (one large and one small) and tie them together with a wired pick.

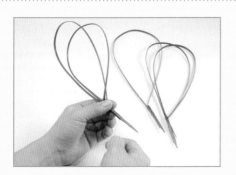

Technique 6

To create a bow shape out of steel grass, take one or two stems of steel grass, shape them into loops and tie the ends together using wired picks. Make single or double loops and insert them on opposite sides of the foam to mimic a bow shape. In my arrangement, I combined double and single loops in each side to add further volume to the bow.

Orchids with Limes

[CONTAINER]
Bowl-shaped container

[MECHANICS]
Floral foam (sphere shape)

[MATERIALS]
Lime
Hala leaves (or flax leaves)
Cymbidium (green and yellow)
Moss (if necessary)

STEP 1

Place the sphere-shaped foam into the container. Insert wooden picks (I used wired picks with the wire removed) into each lime and place them on the foam to cover the rim of the container.

STEP 2

Add folded hala leaves (see Technique 7) between the limes. You may use flax leaves instead of hala leaves, depending on their availability. Both are pliable, easy to work with, and they look very similar.

STEP 3

Arrange green and yellow cymbidiums all around so that the arrangement can be viewed from all angles.

STEP 4

To completely cover the foam, attach whole limes or limes cut in half to wooden picks and place them between the cymbidiums. Moss can be used to cover the foam around the rim of the container, if necessary.

THE FINISHED ARRANGEMENT

Here is the finished arrangement after the additional limes and moss cover the foam completely. Pictured on page 17.

Technique 7

My technique for folding the hala leaves was inspired by origami, or Japanese paper folding. First, split the hala leaf down the middle lengthwise. Then cut it to achieve your desired length. Note that both ends of the leaf are cut diagonally so that the line looks clean. Then fold the cut leaf in half as shown.

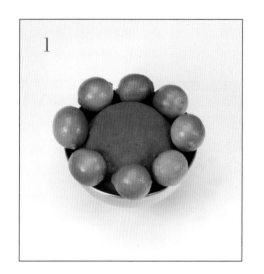

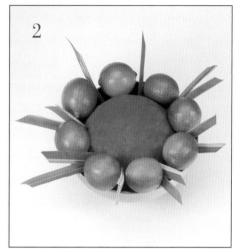

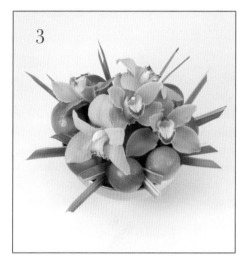

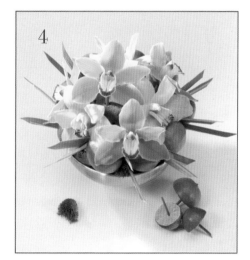

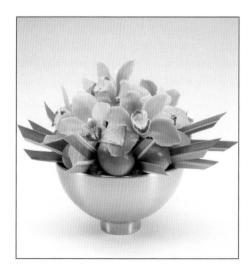

Straight & Curved Lines in Harmony

[CONTAINER]

Rectangular ceramic container

[MECHANICS]

Floral foam

[MATERIALS]

River cane
Raffia
Hydrangea (blue and green)
Ti leaves
Steel grass
Moss

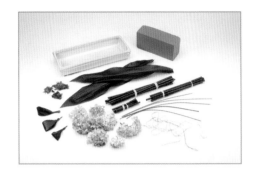

STEP 1

Place the foam inside the container, arrange the moss uniformly on top and pin it in place using U-shaped green wire (see Technique 21).

STEP 2

River canes are very hard to cut, and therefore you'll need to saw them with a small handsaw. Use the handsaw to cut them into groups of four different lengths and tie each group together with raffia. Place the river canes on the right and left side of the container as shown. Note that the taller, thicker grouping is placed on one side opposite the single, shorter group in order to create an asymmetric composition. The larger group is also tied together as a whole to help hold it up.

STEP 3

Cut the hydrangeas into small sections and arrange them around the river cane to add volume (see Technique 8).

STEP 4

Insert folded ti leaves among the hydrangeas (see a similar method in Technique 5). These strongly-colored leaves are placed as an accent between the softly-colored hydrangeas to harmonize the color scheme of this arrangement.

THE FINISHED ARRANGEMENT

Add the overlapping bridged lines of steel grass lengthwise and from front to back as shown. Note how the lines of steel grass are used to connect the two main sections of this arrangement and draw them together into one cohesive whole. Pictured on page 18.

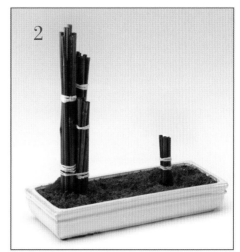

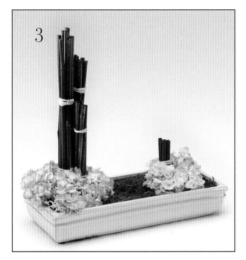

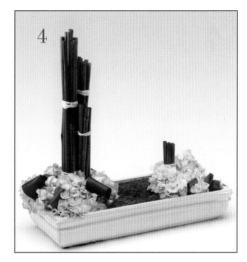

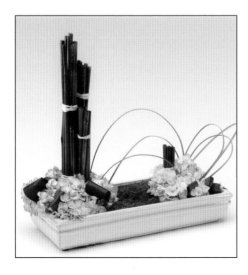

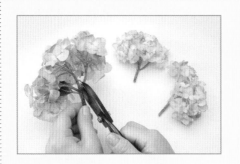

Technique 8

Cut each big hydrangea into small parts and then support them with wired picks (if necessary). Then insert each piece into the foam to create volume.

Hydrangeas amid Dogwood Branches

[CONTAINER]

Cylindrical glass container

[MECHANICS]

Floral foam

[MATERIALS]

Dogwood
Hydrangea
Hosta leaves
Aspidistra

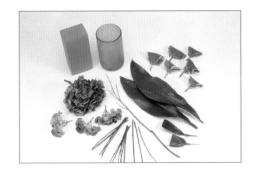

STEP 1

Cut floral foam to fit the container so that it stands about one inch over the rim. Insert the folded hosta leaves into the foam so they cover the rim of the container (see Technique 9).

STEP 2

Arrange the hydrangeas into a ball shape in the center of the container.

STEP 3

Insert bundled groups of dogwood at multiple angles among the hydrangeas (see Technique 10).

THE FINISHED ARRANGEMENT

Add small folded aspidistra leaves among the hydrangeas (for a similar method, see Technique 5). Pictured on page 19.

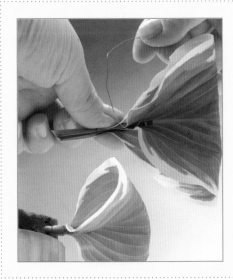

Technique 9

Fold the hosta leaves in half. Place a wired pick along the stem as shown and wrap the wire around the stem. The pick helps secure the hosta leaves to the foam.

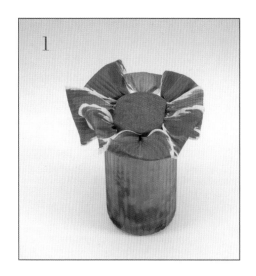

1

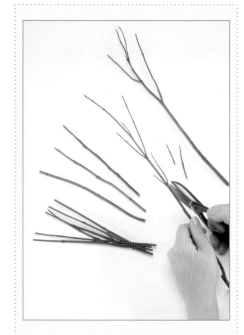

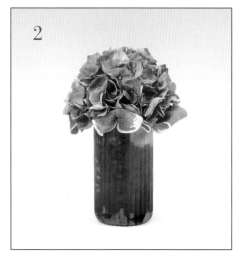

2

Technique 10

To make the bundled dogwood, first trim all the small branches from your main branches. Then cut your main branches into roughly equal pieces six to eight inches long, depending on the size of your hydrangeas. Bundle small groups of branches and tie them together using green wire.

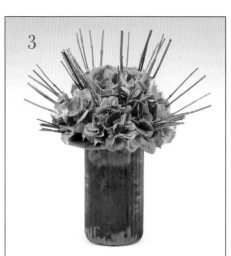

3

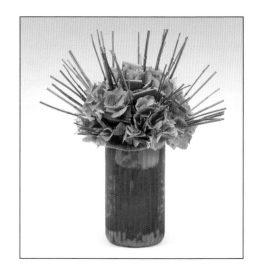

Floral Gift Box

[CONTAINER]
Square glass container

[MECHANICS]
Floral foam

[MATERIALS]
Rose (green and white)
Flax leaves (or hala leaves)
Horsetail
Small white gravel

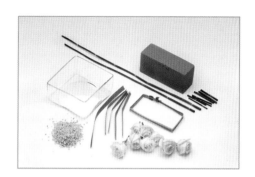

STEP 1

First, create two square "ribbons" to be used later. Split a flax leaf lengthwise down the center into two pieces. Wrap the two halves around the container (not too loosely or firmly) and use tape to secure the ends together. Slide the leaves off and set them to the side.

STEP 2

Place your foam in the container and cover it with gravel. Slip the two square lines of flax leaves back around the container at right angles—much like a ribbon wrapped around a package. (Hide the tape used to attach the leaves at the bottom of the container.)

STEP 3

Cut a group of horsetail so they will stand slightly above the lip of the container and place them in one corner section.

STEP 4

Place looped flax leaves in the opposite corner of the container (see Technique 11).

THE FINISHED ARRANGEMENT

Arrange the roses in the remaining two corners. Add some stones to cover the foam if necessary. (I find it helpful to use a small spoon for this.) Pictured on pages 20–21.

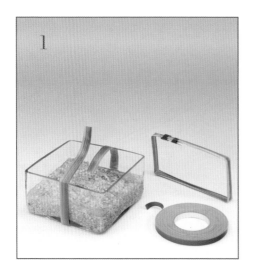

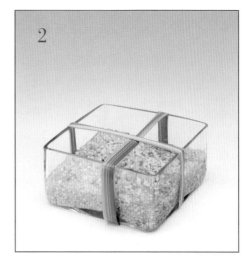

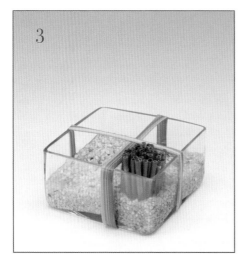

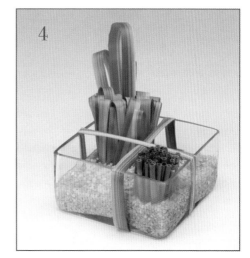

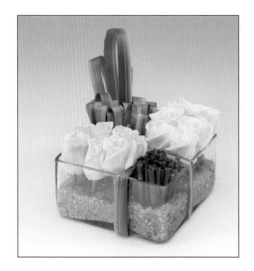

Technique 11

Trim both ends of the flax leaves straight. Depending upon the width of your leaves, you may want to split them lengthwise down the center. Then bend them into a looped shape and insert both ends together into the foam. Making your loops different heights will lend visual "rhythm" to the arrangement.

Roof over Dahlias

[CONTAINER]

Round tray-type container

[MECHANICS]

Floral foam

[MATERIALS]

Horsetail
Raffia
Dahlia (yellow and white)
Galax leaves
Moss
Small stones or pebbles

STEP 1

Place the floral foam in the container and cover the foam with moss using U-shaped green wires to hold it securely (see Technique 21). Then place the pebbles around the foam. The pebbles are not only decorative, but also help to stabilize the foam in the container during transport.

STEP 2

Tie the horsetails into small groups using the raffia and place them upright together on the moss to create a roof-like shape (see Technique 12).

STEP 3

Arrange the galax leaves beneath the horsetail lines, so that the leaves overlap slightly, to add some volume.

THE FINISHED ARRANGEMENT

Arrange the dahlias on the galax leaves. Place the dahlias under each group of horsetail lines so the arrangement can be viewed from multiple angles. Pictured on page 22.

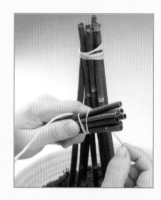

Technique 12

Decide the length of the horsetails based on the size of your dahlias. Larger dahlias will require longer horsetail lines to maintain the right proportion. Cut the horsetails into three groups of roughly equal size and tie them with the raffia. When placing each group on the foam (covered with moss), try to open the bottom parts of the horsetail lines to create a shape like a triangular roof. Make sure each horsetail is inserted firmly into the foam.

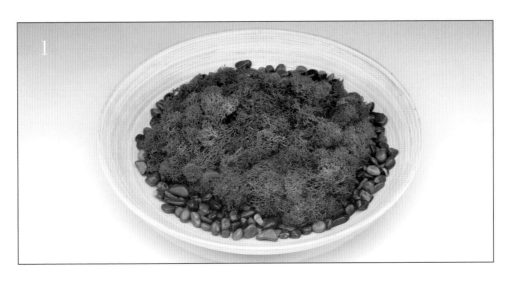

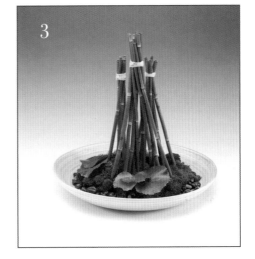

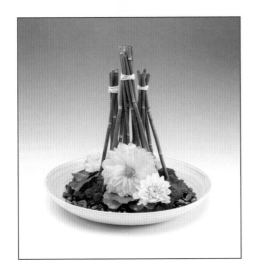

Tray of Calla Lilies

[CONTAINER]

Plastic cups
Tray

[MECHANICS]

Floral foam

[MATERIALS]

Calla lily
Asparagus foliage
Lily grass
Aspidistra
Monstera leaves

STEP 1

First, cut the aspidistra leaves into lengthwise pieces that are about as wide as the height of the plastic cups. Then wrap the plastic cups with aspidistra leaves using double-sided tape and place some foam inside each cup. (See the Basic Tools section on page 38 describing the use of regular or double-sided tape.) Place the monstera leaves inside the tray and display the cups on top of the monstera leaves.

STEP 2

Place the asparagus in the cups so the floral foam is covered from all angles (especially the foam nearest the rims of the cups).

STEP 3

Insert the calla lilies into the cups. Arrange them so they can be viewed from all angles.

THE FINISHED ARRANGEMENT

Add both curved and natural lines of lily grass among the calla lilies (see Technique 13). Note that the calla lilies are cut rather short in order to emphasize the lines of lily grass. Pictured on page 23.

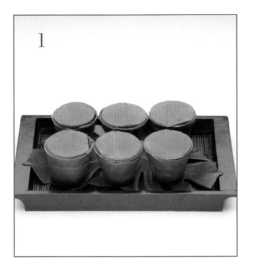

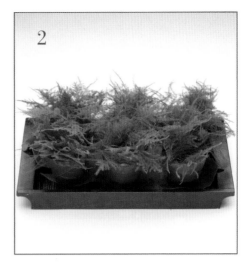

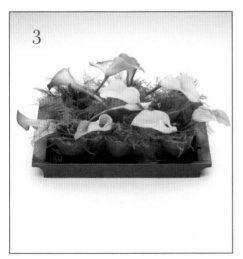

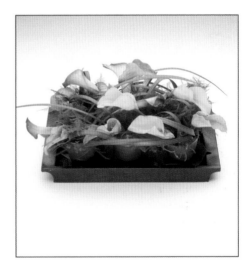

Technique 13

To create a curved line, first insert the thicker (or root) end of the lily grass into the foam. Then, determine your desired length. Cut the grass diagonally as appropriate, and insert the other end of the grass into the foam to form a curved "bridge" shape. To create a "natural" line, first cut the bottom root end to create the desired length, insert this end into the foam, and then just let it lie naturally among the other materials.

Horsetail Garden Fence

[CONTAINER]

Rectangular glass container

[MECHANICS]

Floral foam

[MATERIALS]

Gerbera
Horsetail
Red bullion wire
Fine black gravel

STEP 1

Place the floral foam in the center of the container, leaving some space between the foam and the sides of the container.

STEP 2

Place gerberas facing the front and back of the container so the arrangement can be viewed from both sides.

STEP 3

Cover the foam with gravel using a small spoon, which makes it easier to cover the foam between the gerberas.

THE FINISHED ARRANGEMENT

Arrange tied horsetails in the center of the foam (see Technique 14). Look at the arrangement from the side and top and add additional gravel to cover the foam completely, if necessary. Pictured on page 24.

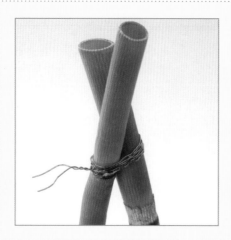

Technique 14

In this arrangement, two intersected lines of horsetails are tied together with thin wire. Simply arrange the horsetails as you like, wind the wire around them a few times, twist the ends together, and trim any excess wire. Place the tied horsetails in the container, then cut them about the same height to create cleaner lines. I used red wire when I tied the horsetails to match the gerberas.

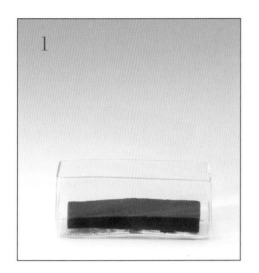

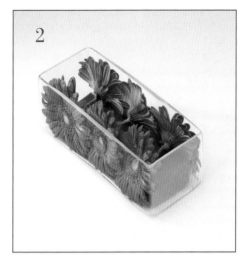

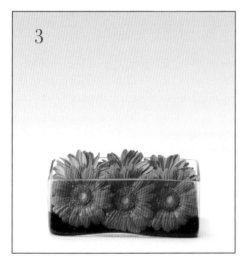

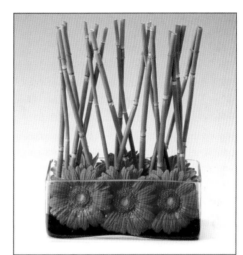

Floral Landscape

[CONTAINER]

Rectangular ceramic container

[MECHANICS]

Floral foam

[MATERIALS]

Horsetail

Iris

Chrysanthemum spray (green and yellow)

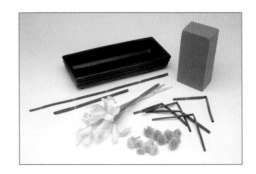

STEP 1

First, lay the horsetail on the floral foam in an "X" pattern and pin it down securely using U-shaped green wire (see Technique 21). Then bend the horsetails into assorted triangular shapes and place them on the left side of the container covering that portion of the foam.

STEP 2

The foam in the container should now be divided into four sections by the X-shaped lines. Cut the green and yellow chrysanthe-mums from the spray. Leave just enough of the stem to fasten each flower securely to the foam. Then place each individual flower into the appropriate section to create the alternate sections of yellow and green as shown.

THE FINISHED ARRANGEMENT

Finally, arrange the iris between the triangular-shaped horsetails. Add tied iris leaves to finish the arrangement (see Technique 15). Pictured on page 25.

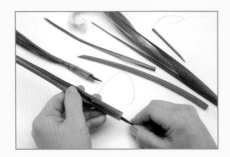

Technique 15

I added these tied iris leaves alongside the flowers to create the image of iris in the garden. Select a few excess leaves and tie them together using the wired picks as shown. I think this subtle, realistic touch adds a lot to the arrangement.

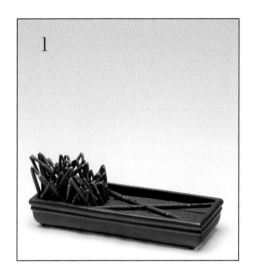

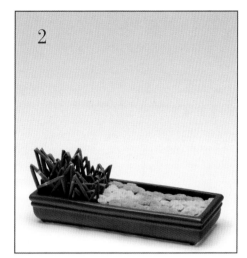

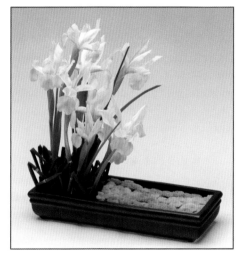

Horsetail Lines with Dahlias

[CONTAINER]
Square glass container

[MECHANICS]
Floral foam

[MATERIALS]
Horsetail
Dahlia
Moss

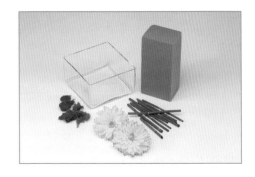

STEP 1

Place square-shaped foam inside the glass container, leaving some space between the foam and the inside of the container. Next cut the horsetails to cover the foam on all four sides. Note that I cut the horsetails into groups of two different lengths in order to fit them together around the foam, with the shorter groups tucked between the longer groups at right angles.

STEP 2

Place moss on top of the horsetails so that each side of the foam is completely covered, except for the top.

STEP 3

Insert horsetails into the foam from the right and left and cut the end of each horsetail diagonally (see Technique 16). One side is cut longer than the other one to create an asymmetric composition.

THE FINISHED ARRANGEMENT

Arrange the dahlias at the center of the horsetails. The dahlias are arranged to be viewed from multiple angles and are cut short to cover the foam and so the horsetails may be clearly seen. Pictured on pages 26–27.

Technique 16

The end of each horsetail is cut diagonally, instead of flat, for added detail.

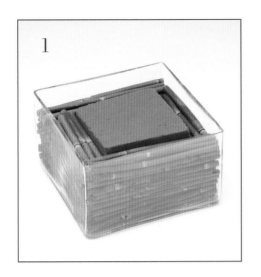

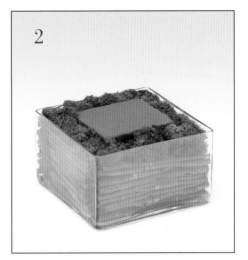

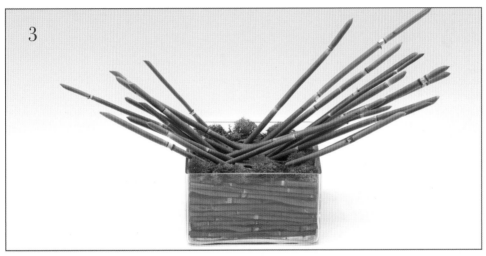

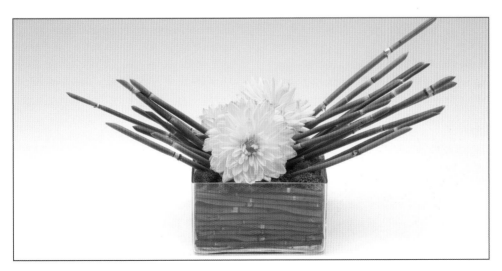

Bamboo & Orchids in Moss Garden

[CONTAINER]
Square ceramic container

[MECHANICS]
Floral foam

[MATERIALS]
Bamboo
Silver bullion wire
Silver aluminum wire
Asparagus foliage
Dendrobium
Moss

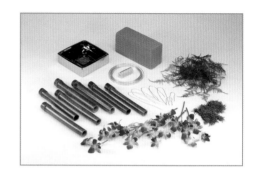

STEP 1

Bamboo is ordinarily sold in long pieces. I used a handsaw to cut my bamboo into the shorter lengths shown here. You should likewise cut your bamboo into shorter-length pieces proportionate to the size of your container. Insert the foam into the hollow center of the bamboos by pressing the end of each bamboo into the foam. Insert the foam as far as it will go into each bamboo, or else the foam is apt to sink down later.

STEP 2

Make sure that the foam sits about one inch higher than the rim of the container so the bamboos will sit securely in the foam. Tie the bamboos together with bullion wire at the top and bottom to hold them together and keep them standing. I used silver wire to match the container.

STEP 3

Cover the floral foam in the container completely with moss. Bend the thicker gauge green wire into a U-shape and use it to pin the moss on the foam (see Technique 21).

STEP 4

Insert the asparagus into the foam inside of the bamboos. I arranged them symmetrically so the right and left sides of the asparagus are in proportion.

STEP 5

Insert the ends of the U-shaped silver aluminum wires into adjacent bamboos as if creating a small bridge (see Technique 17). These wires are used not only as a line element but also function to help keep the bamboos standing securely in the foam.

THE FINISHED ARRANGEMENT

Insert the dendrobium into the foam inside of the bamboos. Arrange a few of the dendrobium on the moss in the container. You can use wired picks to help attach the dendrobium to the moss-covered foam, if necessary. Pictured on page 28.

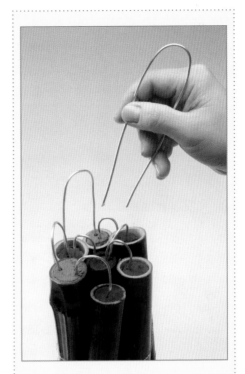

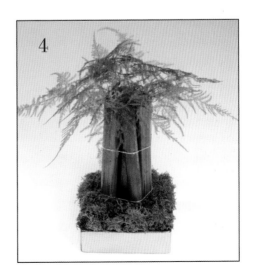

Technique 17

I bent pieces of silver aluminum wire into a U-shape and inserted them into the floral foam in the bamboos. This adds a line element to the arrangement and also helps to keep the bamboo standing on the foam during transport.

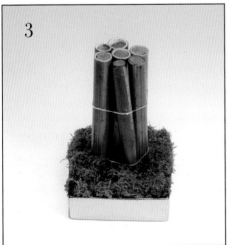

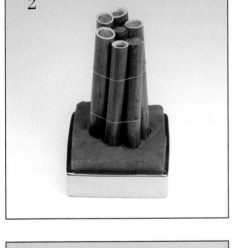

71

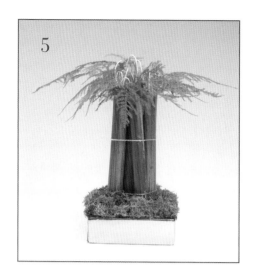
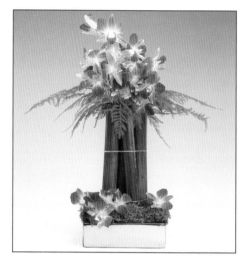

Natural Lines in Basket

[CONTAINER]
Basket
Cylindrical glass container

[MECHANICS]
Floral foam

[MATERIALS]
Peony (dark pink, pink, and white)
Bear grass
Aspidistra

STEP 1

Roll up a few aspidistra leaves and place them along the inside of the glass container, then put the foam in the center. Alternately, you may find it easier to put the foam in first and then wrap it with aspidistra.

STEP 2

Set the glass container in the basket and arrange the peonies on top, making sure to cover the rim of the container. Also, face the peonies in multiple directions so the arrangement may be viewed from various angles.

STEP 3

Tie stems of bear grass into small groups using wired picks and arrange them loosely between the peonies. Pull the stems slightly apart to create flowing, natural lines of bear grass as opposed to rigid groups.

THE FINISHED ARRANGEMENT

Roll the aspidistra leaves and add them to the arrangement (see Technique 18). Pictured on page 29.

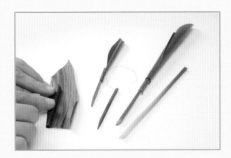

Technique 18

Cut the aspidistra leaves into small sections and trim their top ends diagonally. For shorter leaves, roll and tie them with wired picks. For longer leaves, use a cut stem and attach it to the rolled leaves with wire.

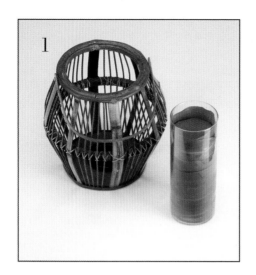

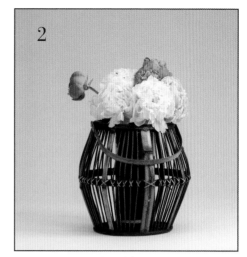

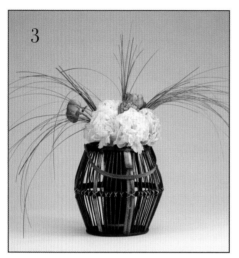

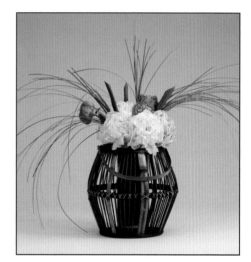

Calla Lilies & Green Grapes

[CONTAINER]

Round ceramic container
Plastic liner

[MECHANICS]

Floral foam

[MATERIALS]

Calla lily
Green grapes
Monstera leaves
Aspidistra

STEP 1

First, cut the aspidistra leaves into lengthwise pieces that are about the same height as the plastic liner. Wrap the plastic liner with aspidistra leaves using double-sided tape and then put your foam inside of the liner. (See the Basic Tools section on page 38 describing the use of regular or double-sided tape.) Lay your monstera leaves in the container and then place the liner (wrapped with aspidistra) on top as shown.

STEP 2

Insert a small wire or pick into each grape and attach the grapes one by one into the foam (see Technique 19). Add enough grapes to cover most of the foam and hide the rim of the plastic liner, but leave some space to insert the calla lilies later on.

STEP 3

Arrange the longer calla lilies in one direction and one short calla lily going the other direction. I incorporate some natural lines of calla lily as well as some slightly curved lines (see Technique 20) for those stems with flowers. I

also make extra curved or bridge-shaped lines, without flowers, using leftover stems from the calla lilies that I cut shorter than the rest.

THE FINISHED ARRANGEMENT

Add a few more grapes to cover the foam completely. Pictured on pages 30–31.

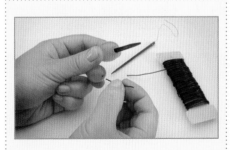

Technique 19

Cut short pieces of wire and insert them into the smaller grapes as a support to attach them to the foam. I also use wired picks cut short (cut away the wired part and leaving the pointed side) to attach the larger grapes to the foam.

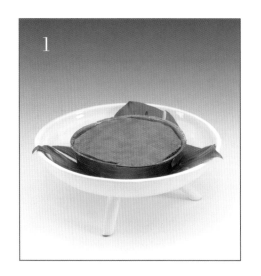

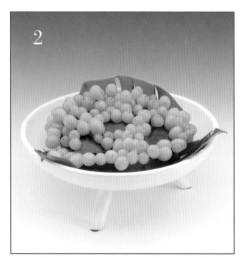

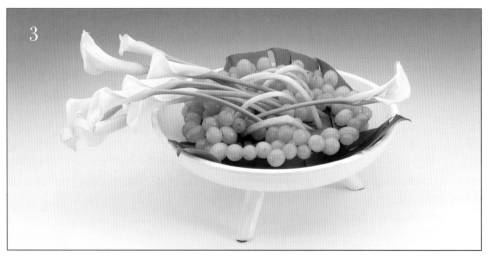

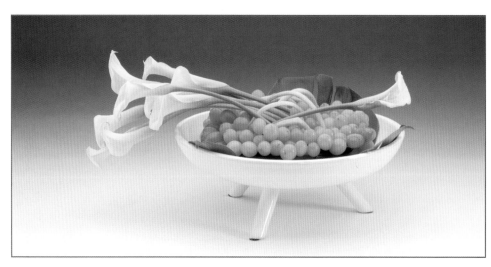

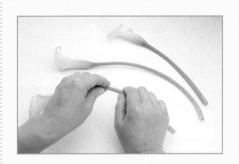

Technique 20

Use two hands to shape the calla lilies into curved lines. Bend the stems into a curved shape, starting from the center and moving slowly outward. Repeat this a few times until you achieve the curve you want. The stem is delicate so be careful not to break it.

Small Container Arrangement

[CONTAINER]

Square ceramic container

[MECHANICS]

Floral foam

[MATERIALS]

River cane
Bouvardia (pink and white)
Croton leaves

STEP 1

Cut a group of river canes about the same length. (The river cane is very hard; I cut it with a small handsaw.) Place the floral foam inside the container so that it lies even with the rim. Lay a group of river canes flat across the top of the container and pin them down with U-shaped green wire (see Technique 21). The river canes are placed unevenly to create more interesting lines.

STEP 2

Trim the croton leaves to about the same size, and insert them into the foam between the river cane (see Technique 22). The croton leaves are arranged to be viewed from both the front and back.

THE FINISHED ARRANGEMENT

Arrange the bouvardia all the way around the leaves, for viewing at multiple angles and to cover the foam. Pictured on page 32.

Technique 21

I often use U-shaped green wire to attach materials to the foam. I simply bend the green floral wire into a U-shape and use it as a pin. While there are many gauges of green wire, I prefer to use thicker wire to make these pins.

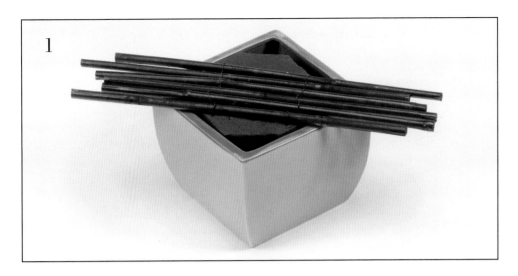

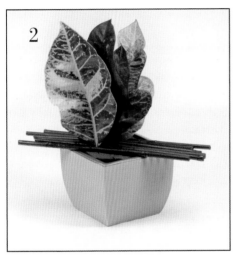

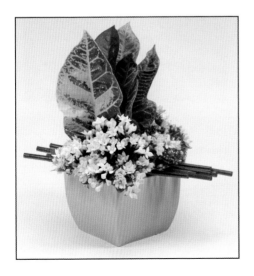

Technique 22

In this arrangement I trimmed the croton leaves to roughly the same size. Trim the bottom part of your larger leaves to match the size of the smaller ones. If you trim along the existing shape of the leaves, the trimmed section looks more natural. Wired picks can be used to support the croton stems and insert them into the foam, if necessary.

Proteas in Round Tray

[CONTAINER]

Wooden tray
Plastic liner

[MECHANICS]

Floral foam

[MATERIALS]

Pussy willow
Metallic wire
Protea (orange and yellow)
Galax leaves

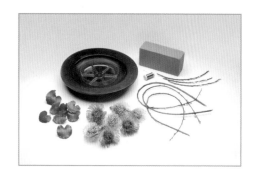

STEP 1

Place the foam in the plastic liner and display it on the tray. If necessary, a temporary adhesive may be used to attach the plastic liner to the container (the temporary adhesive can be detached later). Hide the rim of the liner by placing overlapping galax leaves along the rim. (See the Basic Tools section on page 38, which shows the use of temporary adhesive.)

STEP 2

Choose three sturdy pussy willows to create the main line element. Shape each one into a loose loop and tie it together using wire. I used metallic wire that becomes a separate design element. Pin each branch to the foam securely using U-shaped green wire (see Technique 21). Then tie the three main loops together using wire in order to stabilize it on the container (see Technique 23).

STEP 3

Cut the proteas short and arrange them inside of the looped lines, making sure to cover the floral foam.

THE FINISHED ARRANGEMENT

Shape the remaining pussy willows into slightly curved lines using both hands (see Technique 25). Add them to the arrangement along your main lines of pussy willows. Pictured on page 33.

Technique 23

The three main loops of pussy willows are attached together with metallic wire in order to stabilize them on the container during transport. Use a short piece of wire to loop around the two branches. Twist the wire closed.

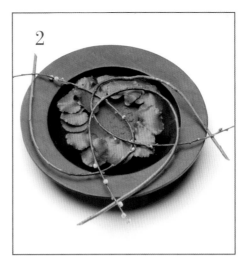

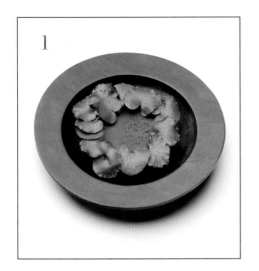

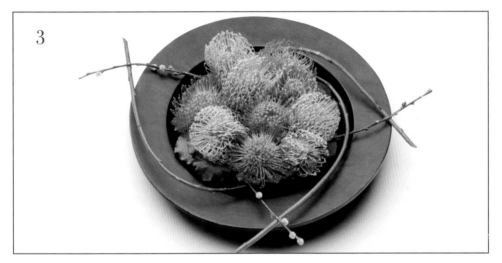

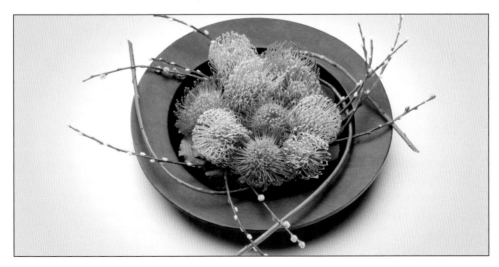

Gerberas in Boat Container

[CONTAINER]
Boat-shaped metal container

[MECHANICS]
Floral foam

[MATERIALS]
Gerbera
Ti leaves
Chrysanthemum spray
Pussy willow

· ·

STEP 1

Display overlapped ti leaves (two to three leaves) lengthwise in the container and place the floral foam on top.

STEP 2

Arrange the gerberas horizontally on the floral foam, keeping them an equal distance apart.

STEP 3

Cut the chrysanthemums from the spray leaving only a short stem on each, but enough to anchor them to the foam securely. Place the individual short-cut chrysanthemums on the foam between the gerberas, making sure to cover the foam completely.

THE FINISHED ARRANGEMENT

Shape the pussy willows into slightly curved lines using two hands (see Technique 25). Add them on both sides of the arrangement. I add more lines to one side than the other to create some asymmetry. Pictured on pages 34–35.

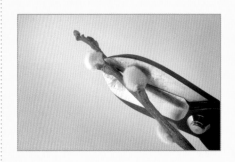

Technique 24

Since I emphasize the line elements in my work, I try to keep clean-looking lines when I cut or trim branches or foliage. When I cut pussy willows, for example, I will make a diagonal cut behind a white-flower section so the cut end looks clean and neat.

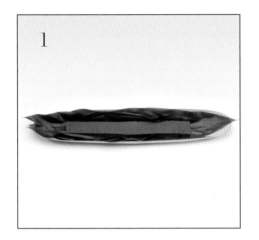

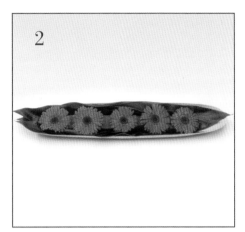

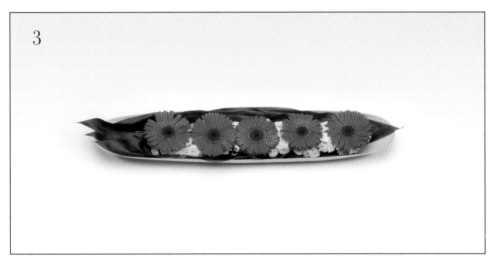

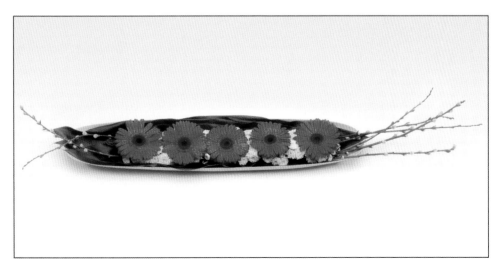

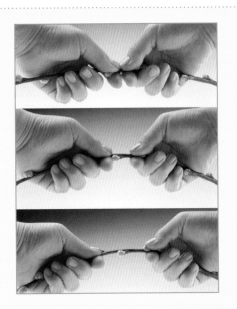

Technique 25

To shape curved lines of pussy willow, use both hands to carefully shape the curved line from the center outward, being careful not to crack the branch. Repeat it a few times as necessary to increase the curved shape.

Orchids amid Fanned Grass

[CONTAINER]
Ceramic dish container

[MECHANICS]
Floral foam

[MATERIALS]
Cymbidium
Hala leaf (or flax leaf)
Steel grass
Galax leaves
Metallic stone (stone-shaped metal)

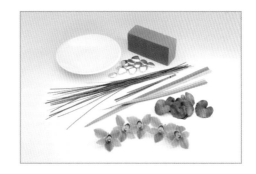

STEP 1
Cut three small, flat circles from the foam, wrap them with split hala leaves (see Technique 26), and place them in the container. Then place the stones around the foam. The stones are not only for decoration but also help stabilize the foam in the container.

STEP 2
Make fan-shaped bundles of steel grass and insert them in the foam at an angle, as shown. The diagonal steel grass lends an added dimension of perspective that mimics the opening of a fan (see Technique 27).

STEP 3
Place galax leaves between the steel grass, covering most of the foam.

THE FINISHED ARRANGEMENT
Arrange cymbidiums among the steel grass. They should cover all of the remaining foam and face multiple directions so the arrangement may be viewed from various angles. Pictured on page 36.

Technique 26
First, split your hala or flax leaf lengthwise down the center into two pieces. Next, cut the floral foam into a round, flat shape that matches the width of your leaves. Then wrap the foam with one of the leaves, attaching it using U-shaped green wire (see Technique 21).

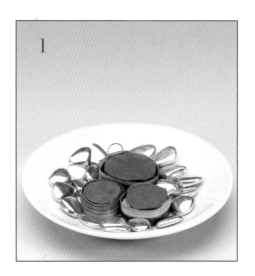

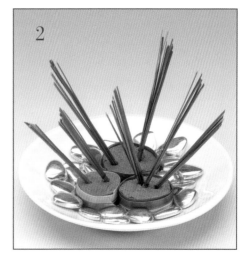

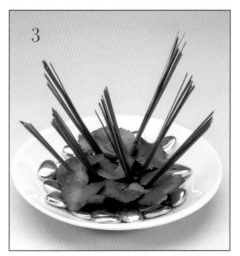

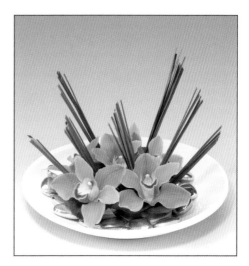

Technique 27

To make fan-shaped lines out of steel grass, create groups of equal length steel grass and tie them together at one end with wire. Then trim the other end of the grasses diagonally.

Acknowledgments

I WOULD LIKE TO EXPRESS MY APPRECIATION to Jennifer Urban-Brown at Shambhala Publications for giving me another wonderful opportunity to write a book.

I would also like to extend my deep appreciation to the people who helped me complete this project: Brian Norkett, for the use of his beautiful home for the interior photos; Urbanest, for use of their many unique containers; photographer Erich Schrempp for his superb photographs; and Ed Campbell for his extensive assistance with my manuscript.

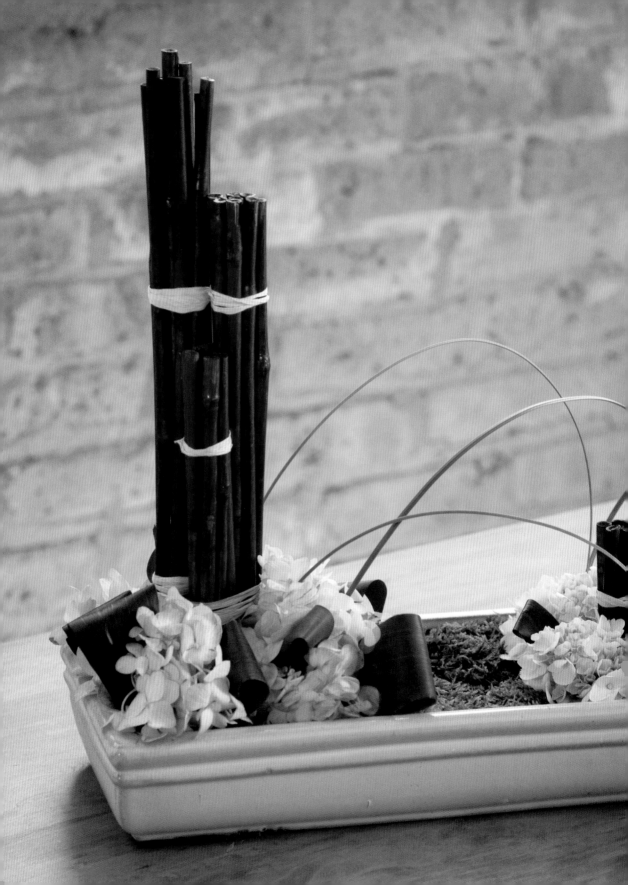

Resources

Below I have compiled some helpful resources, including stores where you can find floral supplies and containers.

[Ikebana Organizations]

Ikebana International
www.ikebanahq.org
This is a worldwide ikebana organization. Their beautiful website explains their many events, activities, and information about different ikebana schools.

[Supplies and Containers]

The following are Chicago-based stores where I usually find interesting containers and ikebana supplies, but they will ship products outside of the Chicago area.

Urbanest
5212 N. Clark Street, Chicago, IL 60640
(773) 271-1000
www.urbanestliving.com
My friends at Urbanest stock some unique containers, including trays I used in this book.

Toguri
851 W. Belmont Avenue, Chicago, IL 60657
(773) 929-3500
They have a varied collection of ikebana containers and tools, including some nice gravel that I used for different arrangements here.

[ONLINE SHOPS]

Stone Lantern
www.stonelantern.com
Ikebana tools

Save-On-Crafts
www.save-on-crafts.com
Ikebana and Western floral supplies

Michaels Floral Supply
www.michaelsfloralsupply.com
Various floral supplies

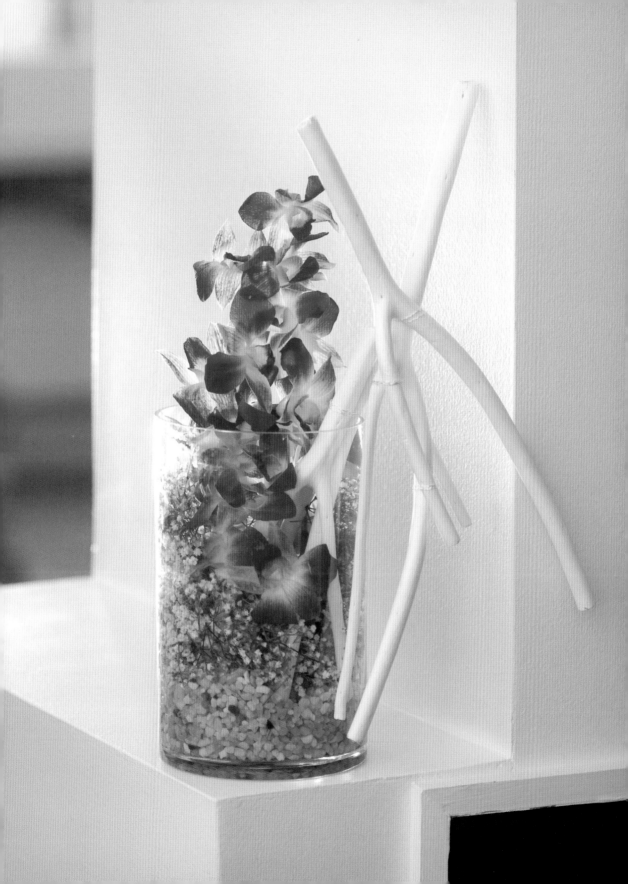

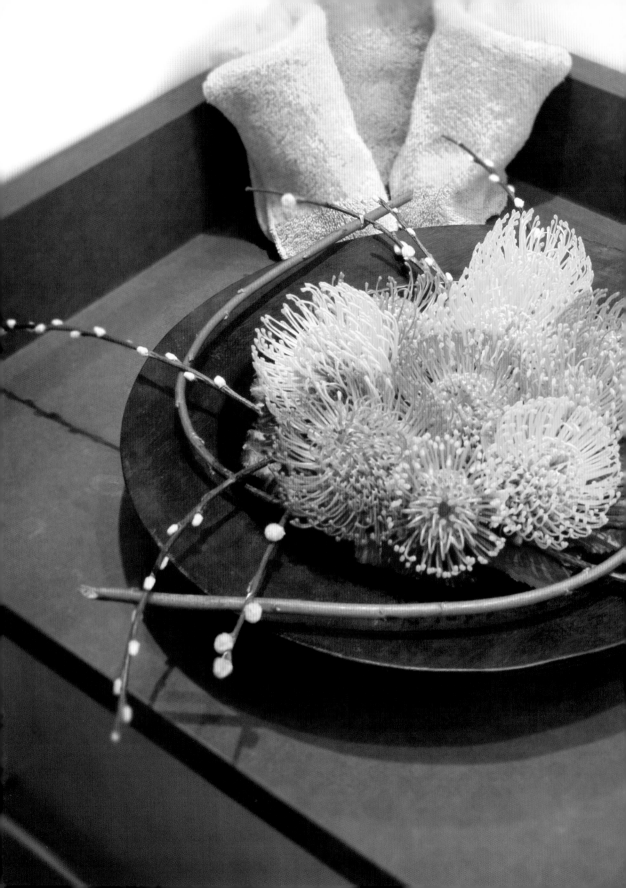

About the Author

KEIKO KUBO was born and raised in Japan. She first studied ikebana as a teenager with her mother and eventually obtained her certificate to teach ikebana. After graduating from college, Keiko came to the States to study at the School of the Art Institute of Chicago and obtained her MFA in sculpture. Keiko later studied Western floral art and further developed her practical skills working in the Chicago floral industry. Her style is a unique blend of three major influences: ikebana, Western floral design, and sculpture.

Keiko is also the author of *Keiko's Ikebana* (Tuttle, 2006) and resides in the Chicago area where she works as an independent floral designer. In addition to teaching floral workshops, she creates original works for clients seeking distinctive arrangements for weddings and other special occasions. Her website is www.ikebanabykeiko.com, and she can be contacted at keiko@ikebanabykeiko.com.

ERICH SCHREMPP fell in love with the magic of images the first time he watched a print develop in the darkroom. In the years since then, he studied the craft, worked as an apprentice, and finally opened the doors to his own studio in 1981. Though darkrooms have given way to computers, the joy of bringing an image to life continues to energize his work. Erich makes his home in Chicago and dedicates the photos in this book to his wife Kathy and two amazing grown children, Skyler and Zander.

93

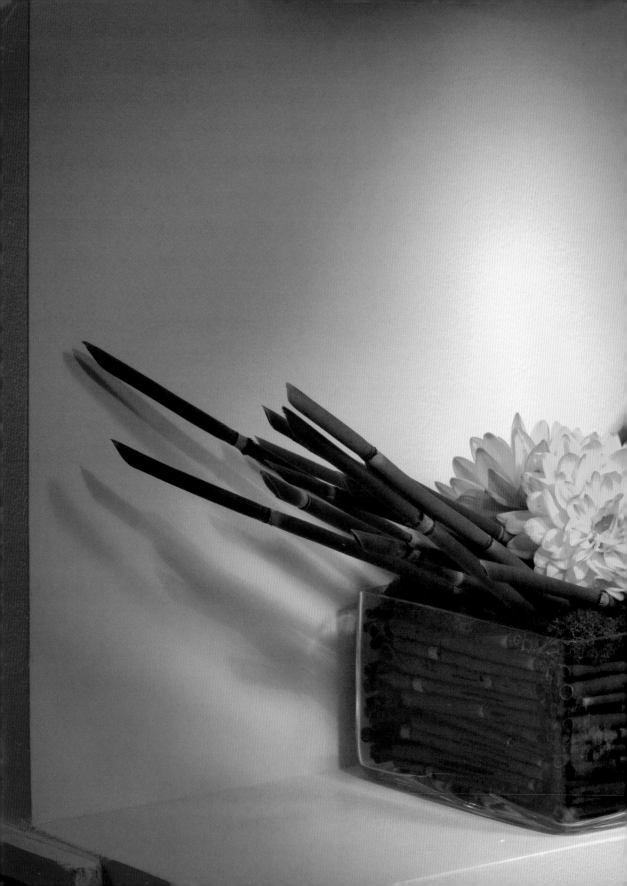

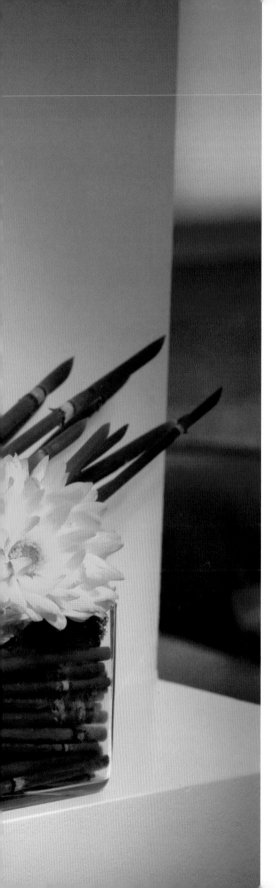

Trumpeter Books
An imprint of Shambhala Publications, Inc.
Horticultural Hall
300 Massachusetts Avenue
Boston, Massachusetts 02115
www.shambhala.com

9 8 7 6 5 4 3 2 1

First edition
Printed in China

⊗ This edition is printed on acid-free paper that meets
the American National Standards Institute z39.48
Standard.
♻ Shambhala Publications makes every effort to print
on recycled paper. For more information please visit
www.shambhala.com.

Distributed in the United States by Random House, Inc.,
and in Canada by Random House of Canada Ltd

Designed by Daniel Urban-Brown

Library of Congress Cataloging-in-Publication Data
Kubo, Keiko, 1962–
Ikebana style: 20 portable flower arrangements perfect
for gift-giving / Keiko Kubo; photographs by
Erich Schrempp.
p. cm.
ISBN 978-1-59030-673-4 (pbk.: alk. paper)
1. Flower arrangement, Japanese.
2. Flower arrangement. I. Title.
SB450.K748 2010
745.92′252—dc22
2010005849